PAINTING
LIGHT &
SHADE

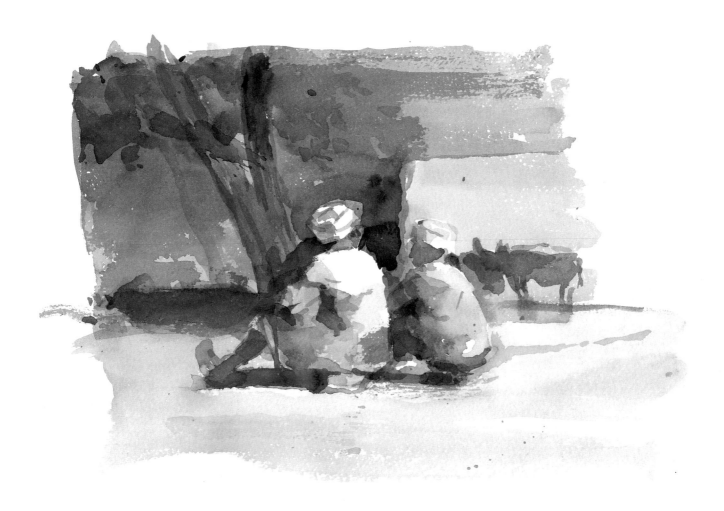

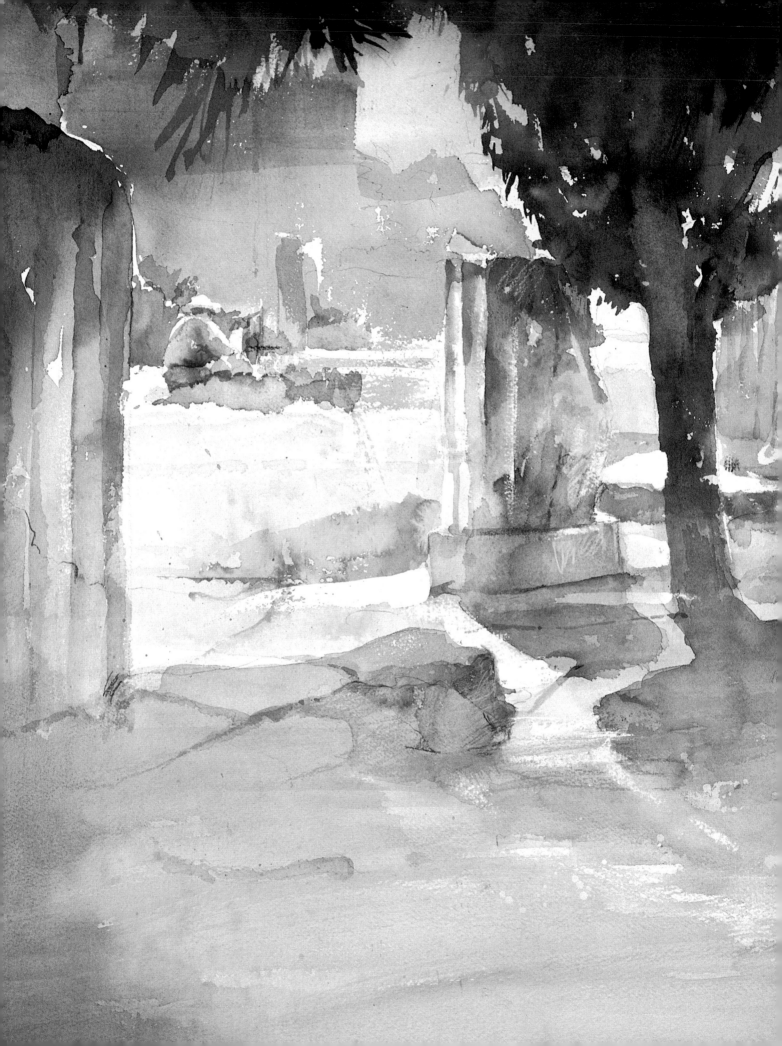

PAINTING
LIGHT &
SHADE

PAUL MILLICHIP

B. T. Batsford Ltd · London

Typeset by Goodfellow & Egan Ltd, Cambridge

and printed in Hong Kong

Published by
B.T. Batsford Ltd
4 Fitzhardinge Street
London W1H 0AH

A catalogue record for this book is available from
the British Library

ISBN 0 7134 7152 2

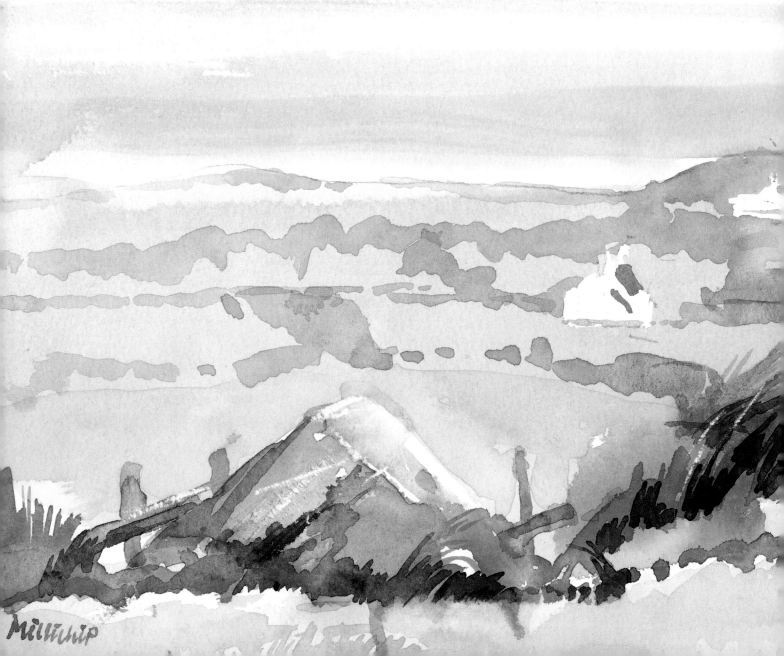

CONTENTS

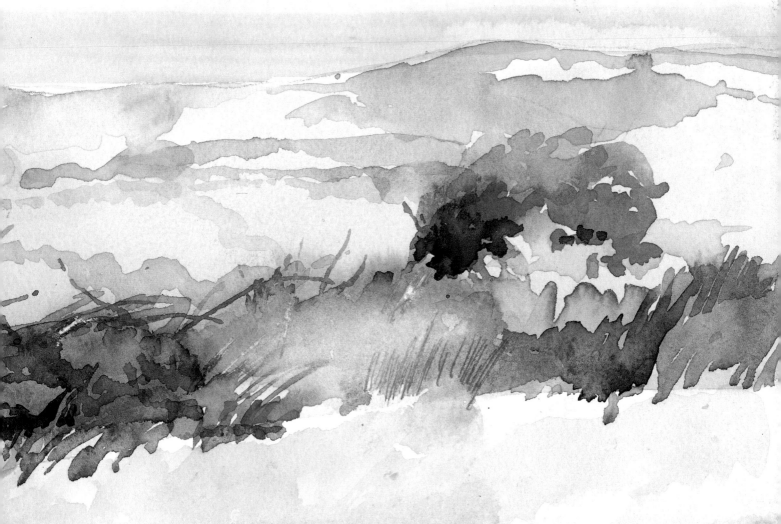

from Y Felin. Pembs

INTRODUCTION

> Every country where the sun shines and every district in it has a theme of its own. The light, the atmosphere, the aspect, the spirit are all different but each has its native charm.
>
> Winston Churchill, *Painting as a Pastime*

October Vine Study

The fruit on this vine was over-ripe, withering and barely visible in the shadow shapes cast by the dry leaves. On a brilliant autumn morning, these intense shadows, which had a lively character of their own, cast on the whitewashed wall, required careful drawing and awareness of the varying reflected light within them. The initial wash was of very fluid blue (French Ultramarine with a little Winsor Blue), applied with a pointed brush to define the sharp shadow edges. While this was still wet I dropped in brushfulls of Alizarin Crimson and a little Yellow Ochre, introduced through a pipette to show warm reflected light. I also began to apply more crimson and some ochre to indicate grapes and yellowing leaves, which were later redefined with crayon work. Watercolour, 35 × 23 cm. (13½ × 9 in.)

The world can never look the same again once you become a painter. A painter's way of seeing sharpens, broadens and deepens the perceptions so that, however skilful or otherwise your painting may be, an increased awareness of your quality of vision is the real bonus that painting brings. This means that painters need to be visually conscious of people and places. To help keep their powers of observation acute, they must preserve a sense of wonder at the world around them. Crucial to this more acute vision is the part played by light in revealing and interpreting that world.

Brilliant sunlight can give significance to shapes, textures and colours which go unnoticed on an overcast day. Softer, cooler light can impart mystery and melancholy to the most mundane of objects. A dusty veiled light can even imply a sense of foreboding. Light models forms, reveals contours and creates mood and atmosphere.

For painters who travel, change of location can mean a change of light, even more importantly than a change of scene. When Turner made his first journey to Italy in 1819, it was the Italian light that left the most abiding impression on him: 'an atmosphere that wraps everything in its own milky sweetness' was how Turner's contemporary Sir Thomas Lawrence described it. After the dull skies of northern Europe, the revelation of a landscape seen under the sun of Italy had the effect upon Turner of enriching his ability to see light in terms of colour.

As he travelled, Turner made copious notes in his sketch books: 'The ground reddish grey-green and apt to purple, the sea quite blue, under the sun a warm vapour, from the sun blue, relieving the shadow of the olive trees dark.' Such notes show the way in which, for a painter, a change of light can bring fresh revelations.

Seventy years later, another artist, Vincent Van Gogh, wrote: 'My house here is painted the yellow colour of fresh butter on the outside with glaringly green shutters. It stands in the full sunlight in the square which has a green garden . . . and over it all is the intensely blue sky.' Like Turner, Van Gogh had left northern Europe and moved south to work. 'Here [in Provence] I feel much better than I did in Paris', he told his brother Theo. 'The fact is that the sun has never penetrated us people from the north.' The results of this move into warmth and sunshine are now famous; the sense of release that it brought triggered the outpouring of brilliant colour we now know so well. To leave Paris for Arles meant a new start amongst new surroundings, above all in a different light.

Although painters have always travelled in search of the stimulation of new sights, it was in the latter part of the nineteenth century that they began in their paintings to record the varying nature of different lights in different places. Many artists sought out locations near water for its reflective as much as its pictorial value. Claude Monet visited London and painted impressions of the River Thames seen in light muffled by fog, while in Venice he recorded the glitter from the water reflected onto the canal-side palazzi. Cézanne painted the rocks and trees near Aix-en-Provence in terms

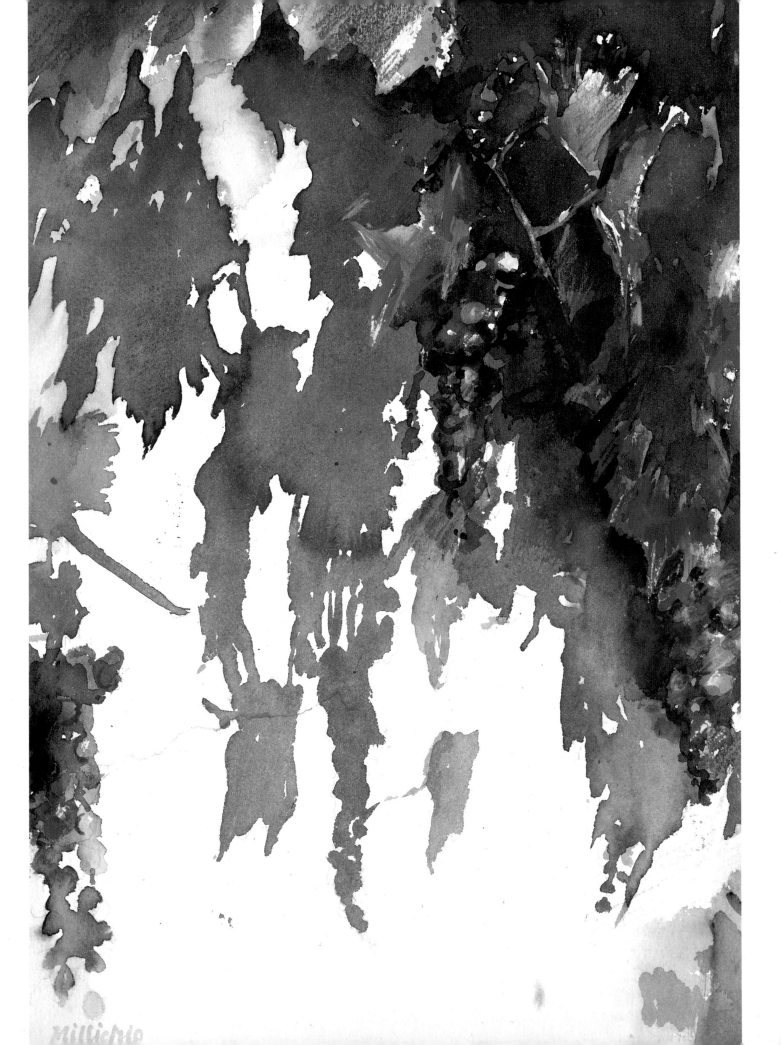

Millichip

of the coloured planes revealed by the clear, sea-reflected light of the Midi. Renoir sought out and painted models whose skin would take the light to advantage. During the latter part of Renoir's life his neighbour and friend in the Midi was Matisse, who liked to use the faded rococo salons of various old hotels near Nice as a setting for his richly patterned interiors. 'The light came through the shutters,' he wrote, 'it came from below like footlights'. He was writing, of course, of the sunlight of the Midi, 'clear yet soft', as an observer described it. It had already influenced other painters besides Matisse, moving them towards clearer and more brilliant colours. Collioure, l'Estaque and St Tropez were amongst the coastal towns of the Midi where Derain, Braque, Dufy and other fauvist painters found subjects. 'Above all the light,' wrote Derain from Collioure, 'a golden tone that suppresses the shadows'.

In Britain, the unique quality of light in the fishing village of St Ives in Cornwall was an important element in attracting painters to work there from the late nineteenth century onwards. Part of the town lies on a peninsula and light is reflected from all sides by the sea onto the grey stone walls of fishermen's cottages. These pervasive effects of light and colour have lent a distinctive character to much of the output of artists working there, with silver-greys and browns predominating in both abstract and figurative works. The paintings of Ben Nicholson, Peter Lanyon and Terry Frost exemplify this local tradition, as does the sculpture of Barbara Hepworth.

Talking of his house and studio in Cape Cod, Massachusetts, the American painter Edward Hopper said, 'There's a beautiful light there, very luminous, perhaps because it's so far out to sea, an island almost.' Hopper's paintings in both watercolour and oil proclaim the special quality of light on the eastern seaboard of New England. Low-angled, and giving deep and mysterious shadows, this light pervades most of Hopper's work, and not

Fishing Fleet, Baga Beach

See pp. 114–15

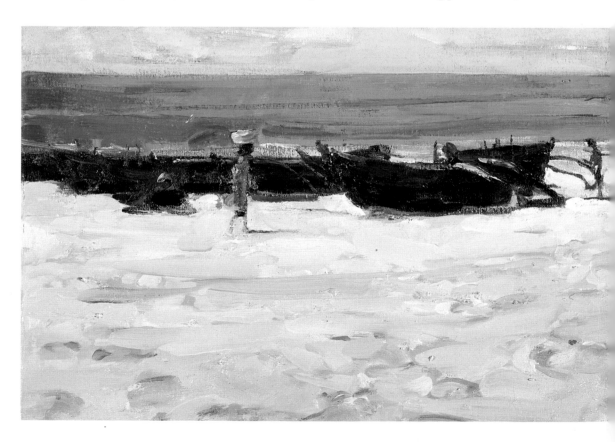

only his studies of coastal scenes. Whether Hopper concerns himself with a lighthouse set against the sky, or a freight car in a Gloucester siding, or with interiors and figures, a low, raking sunlight, clarified by pure coastal air, lends sculptural weight and mystery to his paintings. In late works, such as *Sun in an Empty Room*, the light and the shadows it casts have become the reason for the painting, giving it purpose and mystery at the same time.

This restless search by many painters for an ideal working light could be seen as the pursuit of a means of expression. Today, accelerated travel makes almost instant comparisons possible between one country and another, revealing their special qualities of light. Although we might feel nostalgia for the more leisurely voyages of the past, it is true to say that a sharpening of vision can often come from the contrasts made possible by a rapid air journey, for example when we board a plane in mist or rain and leave it in brilliant southern sunshine. These days

the South Sea Islands can be reached easily by would-be Gauguins! Modern travel has changed the world for painters as for everyone else. Those in search of a primitive or unspoiled way of life may find this elusive, but beautiful places still remain, and the intensity of the sunlight on, say, an Aegean island can make a chicken coop a palace, with its quality of diamond-sharp brilliance.

The paintings in this book have been chosen especially to show how I registered my reactions to the prevailing light in certain parts of the world. When I visit a country, I try not to bring preconceived ideas to bear on the things I paint, but attempt to let the light and the subject speak of their special qualities. The accompanying notes re-create the circumstances under which the paintings were done and recall the techniques and methods used. I hope you may find this helpful when you are a travelling painter.

Paul Millichip

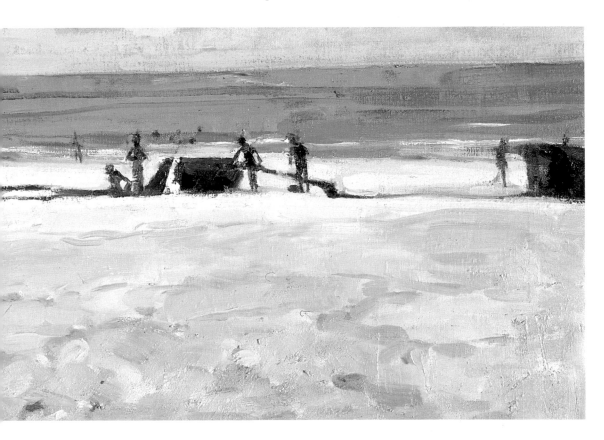

THE GREEK ISLANDS

The ferryboat from the Greek port of Rafina had the friendly atmosphere of a large village bus. The cargo ranged from concrete mixers to café chairs, from tethered goats to crates of cabbages. Human cargo included returning shoppers, soldiers on leave, relatives bound for a family party, all chattering loudly over coffee in the smoke-laden saloon below decks. However, by the time the boat had visited other islands and, eventually, docked, this cargo was much reduced.

'Welcome to Tinos' declared the illuminated sign on the quayside. It was late on a winter's evening and only five passengers disembarked, including our party of three. A little harbour-side hotel accommodated us, and the following sunlit morning brought my first-ever experience of the clarity of Greek-island light. A walk along the quayside revealed to me as a painter the ability of light to transform everything it touches and impart a sense of significance to every object down to the tiniest pebble. I noticed how, on such a morning, cast shadows are intense and sharp, becoming sharper as the day progresses but with an intensity which carries reflected light within it, introducing a note of warmth into the coolest of shadows.

Taking a further ferryboat to the island of Mykonos, we found characteristically Cycladic snow-white cubic buildings. To walk between these seemed like experiencing the inside of a cubist painting, with Mondrian-like coloured doors and balconies imposed upon the façades. Lime-washed property

Morning Sun, Symi

Painted from drawings made on site. To achieve the texture of rough lime-washed walls in brilliant sun, I first applied a layer of white oil paint, using palette knife and brush. After allowing about eight weeks for this to dry I added the shadow colours as a series of glazes (oil paint thinned with linseed oil wiped on lightly). Sky and figure were overpainted in opaque impasto, paying careful attention to the depth of colour in the sky. Oil on board, 25 × 30 cm. (10 × 12 in.)

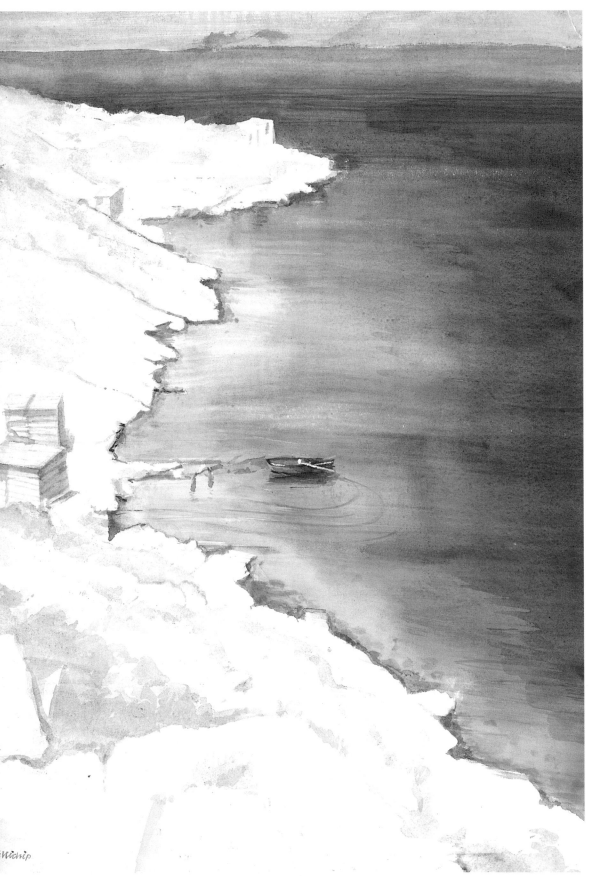

Aegean Shoreline

Late autumn and the dry, sun-bleached rocks and vegetation near the shore contrast with the intense colours of the sea. I drew the shoreline contour carefully in soft pencil and then began making mixtures with my usual basic group of six colours: Winsor Yellow, Yellow Ochre, Cadmium Red, Alizarin Crimson, French Ultramarine and Winsor Blue. I mixed Ultramarine and Winsor Blue to show the intense colour of the deep water just off-shore, tilting my drawing board and flooding large brushfulls of paint across the paper. These drained to a deeper blue on the right. A pointed brushfull of colour was used to follow the coast contour more precisely. While this was wet I flooded in crimson for the deeper waters off-shore. When the painting was quite dry I carefully sponged back into the sea wash and also sponged down the land area. A transparent wash of Winsor Yellow was used to indicate light reflecting from underwater sand and rock. Watercolour, 74 × 53 cm. (29 × 21 in.)

demarcation lines drawn on the streets reinforced the light reflected up from the ground onto paving stones, the under-surfaces of door lintels, balconies and any other projecting features – a quality of bouncing light that is more marked in the Greek Islands than in any other place I know.

On this first visit I started to draw in my sketch book and to study the range of tones and colours in this world of sharp reflected light. I noticed how the intense blue of the sky (this was November and I was to see even more brilliantly blue skies in spring) emphasised the silhouetted shapes of the white buildings. I realised that careful observation of the tonal relationships between the intense sky, the sunlit planes of the buildings and their shadowed sides was part of the key to understanding the representation of objects under a Greek-island light. Increasingly aware of colour, I noticed that the shadows on the sides of the buildings were positively blue, turning to violet in harmony with the sky as the sun climbed higher.

A later visit to Greece found me leaning on the rail of a rusting ferryboat from Rhodes as it clattered and wheezed towards the tiny island of Symi. It is always exciting to arrive by boat in the evening at a Greek island and to see the harbour lights appear out of the dark. Symi's steep-sided harbour was tiered with the lights of its lanes and neo-classical porticoed houses, which gleamed softly under the pale-yellow street illumination. After we landed, a jolly, if in memory somewhat blurred, taverna evening followed. Bottles of Retsina kept appearing on our table with cheery waves from local sponge fishermen – we were celebrating an anniversary. Freshly cooked lobster was proffered and there was dancing and singing to a violin and a concertina.

To look down on the fjord-like harbour of Symi the following morning was breathtaking for a first-time visitor. The

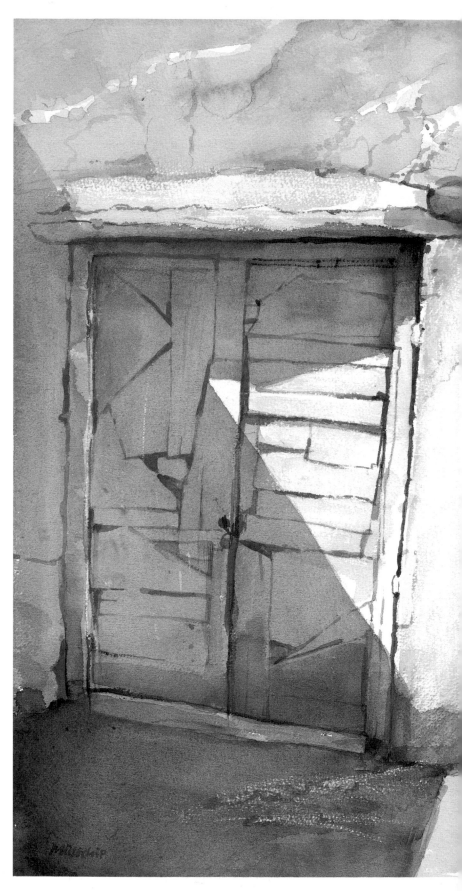

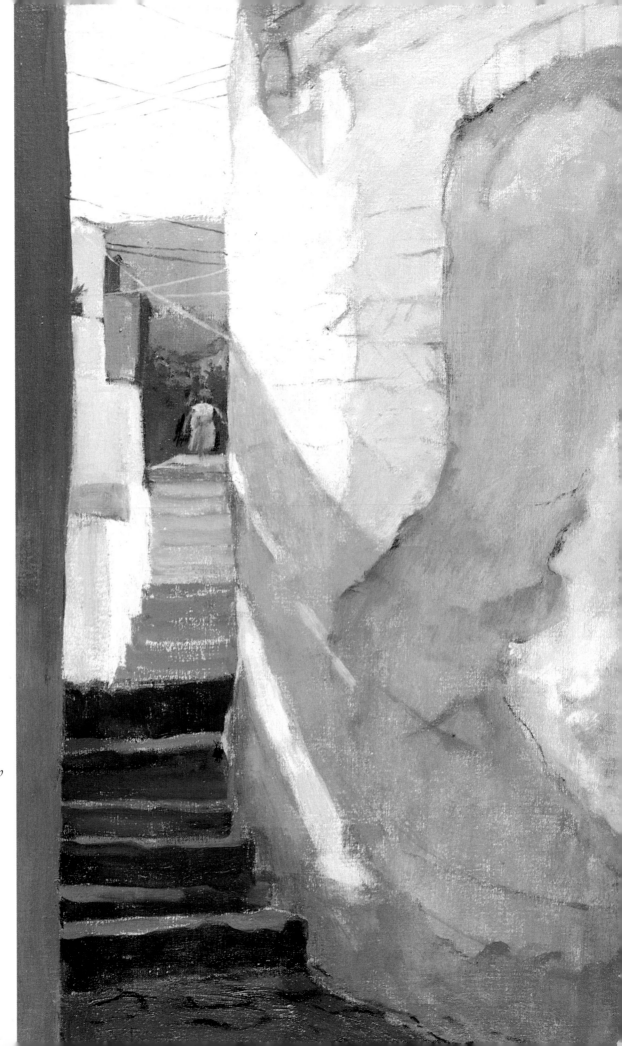

(Left) The Store-Room Door

Obviously a door with a history! This jigsaw of nailed planks had been lime-washed at the same time as the surrounding wall. I loved the vibrant and reflective shadow – painting this entailed careful mixing of a very fluid wash of French Ultramarine, Winsor Blue and Alizarin Crimson (stirred not shaken), with plenty of trials on a separate sheet of paper to ensure the right depth of tone. Watercolour, 56 × 29 cm. (22 × 11½ in.)

(Right) Blue Steps, Symi

A flash of brilliantly coloured steps between backlit, rough-finished walls – blue is said to keep the ants at bay! Working from dark to light, I placed the darker blue steps, keeping the paint thin so that the white canvas showed through. The shadowed wall areas were brushed in vigorously, with the paint scrubbed on more thinly for the paler shadow of the blocked-up doorway on the right. Yellow sky was a useful complementary to the blue steps. The yellow dressed figure was added last to imply scale and point up the colour scheme. Oil on canvas, 76 × 46 cm. (30 × 18 in.)

Harbour Mooring

The brilliantly sharp light of Greece calls for an extended tonal range, with rich dark colours built in. A half-sheet of carefully stretched Arches rough paper provided a base, and I started by using masking fluid to place the boat and mooring ropes. The shallow harbour bed of stones was painted in French Ultramarine. When this was dry I laid a wash grading from violet (Alizarin Crimson, Ultramarine, Winsor Blue) to blue-green (Winsor Blue/ Winsor Yellow). As this dried I slightly tilted my board towards the top of the painting to give more intensity to the upper part and show the darker, deeper water. Masking fluid removed, the strong reflection of the boat called for a bold, near-opaque mixture: Winsor Blue and Winsor Yellow, with a touch of Cadmium Red. The boat's cast shadow, seen through the still, clear water, needed careful drawing to show how it followed the contours of the underwater stones. Yellow Ochre with a touch of Winsor Yellow was washed thinly over the lower part of the now-dry painting to create the greenish shadows. Watercolour, 38 × 56 cm. (15 × 22 in.)

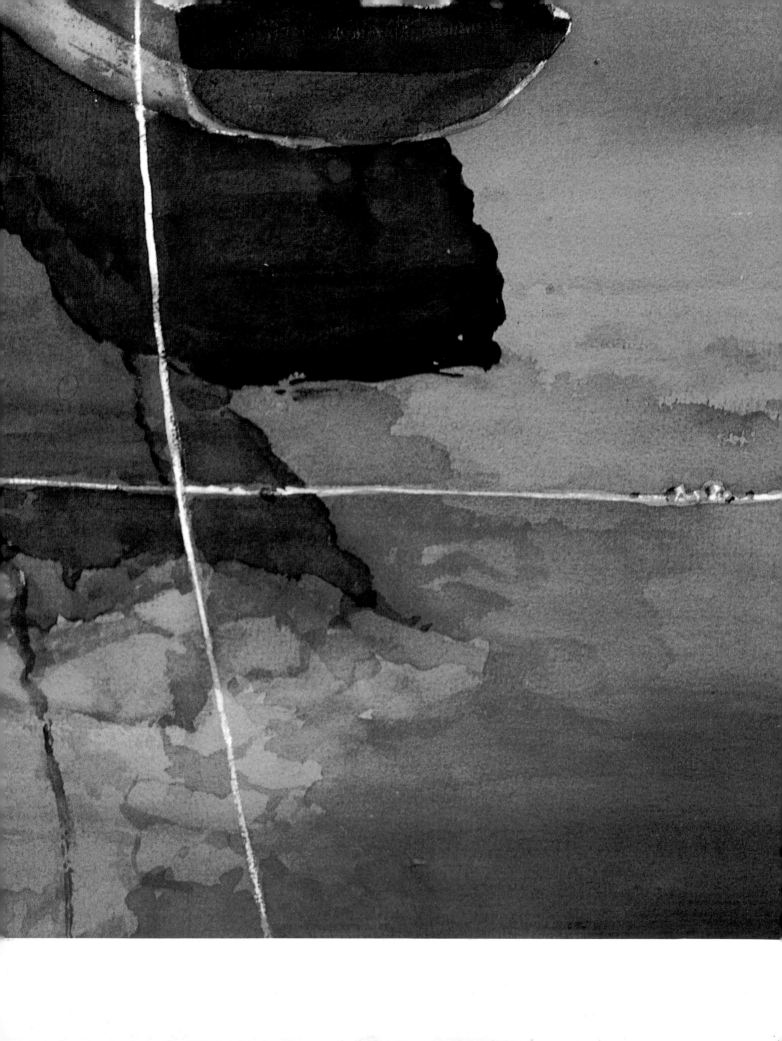

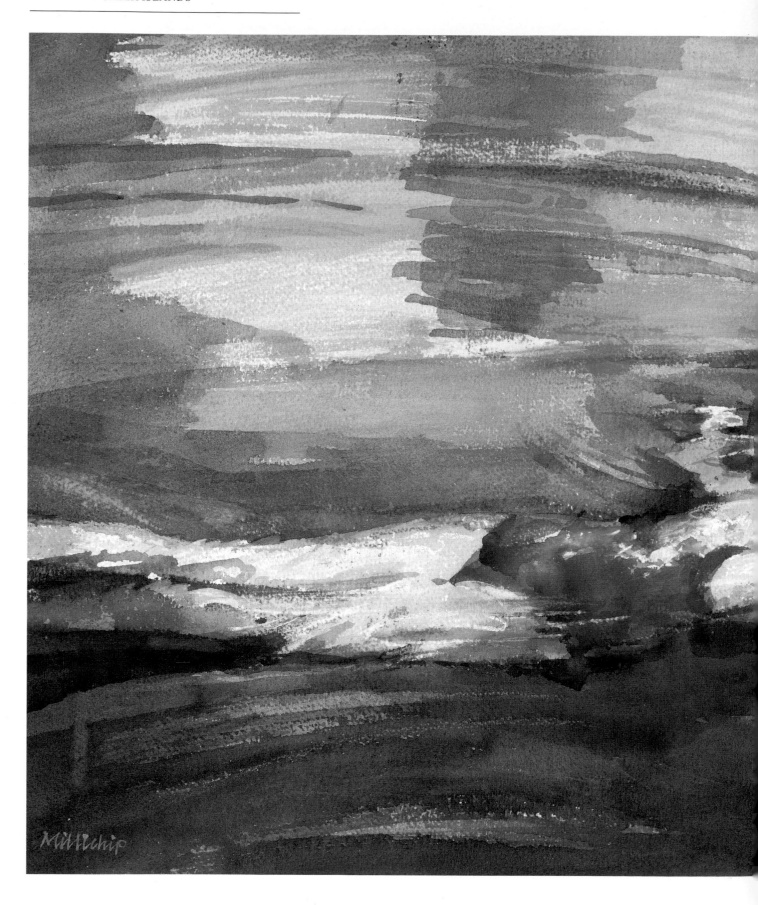

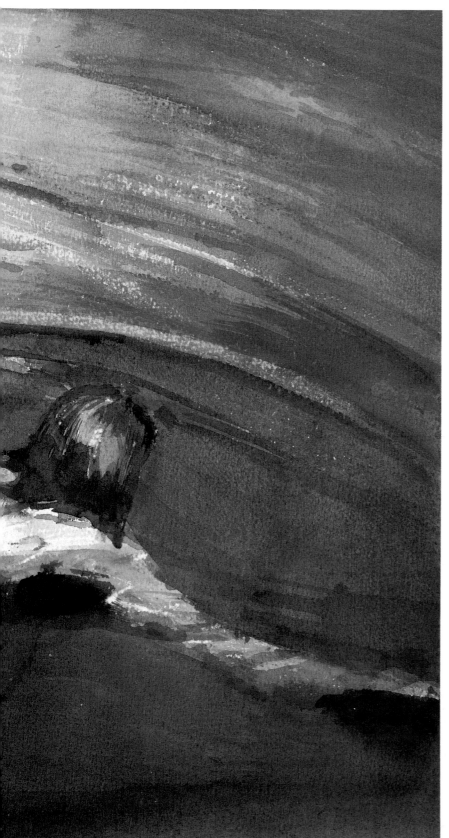

vision was of stone-walled and pink-roofed houses piled behind one another against the blue of the sea – an especial thrill for a painter because of the precise definition of form lent to the scene by the brilliance of the light. However, it was the transparency of the harbour water that attracted me on this visit, water that showed translucent under the clear light, its refracted surface patterns transferred to the ocean floor in a glittering network. I noticed how the boats had this network projected onto their sides as they lay moored, their dark reflections hovering over the shadows they cast on the harbour floor, sometimes giving the illusion of vessels floating in sunlight between air and water. Another visit to Symi the following spring offered a further chance to wonder at the clarity of that water, to see and record how the brown bodies of swimmers appeared pale and greenish as they were submerged.

Visits to other Greek islands followed, confirming my first impressions of the

Rachel at Sigri

I hired a pedal boat and drew and made notes from this vantage point, while my daughter swam for me in the shadow of cliffs whose rocks reflected purple onto the sea. In this unusual light my model's skin showed quite greenish and pale just below the water. Alizarin Crimson with a little French Ultramarine made the dominant colour note here, and I added a little crayon and pastel for ripples and water surface. Watercolour, 38 × 53 cm. (15 × 21 in.)

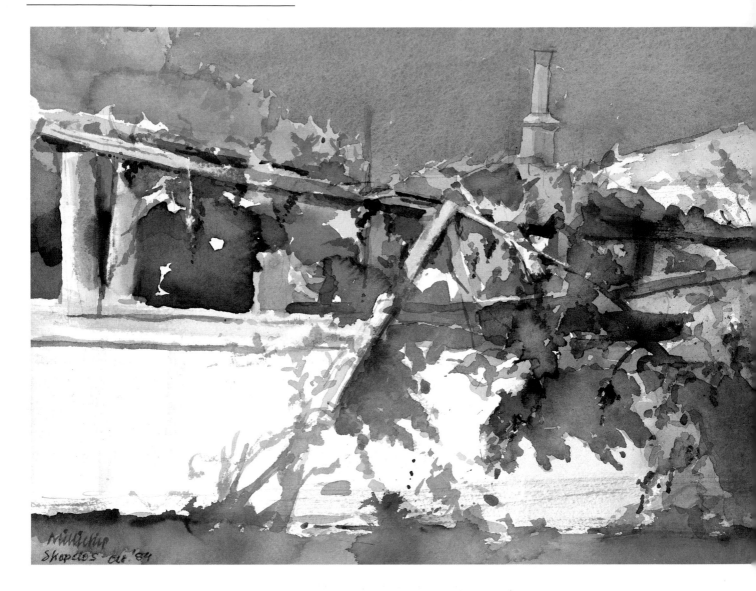

Ruined Pergola and Vine

A quick on-site study to note the effect of mid-morning side light on this tangle of posts, beams and half-dead vegetation. A tonal pencil drawing preceded a monochrome underpainting in French Ultramarine. Greens were achieved with a thin stain of Winsor Yellow over the blue. Watercolour, 26 × 36 cm. (10 × 14 in.)

special nature of the light. I spent many afternoons studying the particular qualities of cast shadows; this study was to become almost an obsession. I saw how the broad, multi-pointed vine leaves threw patterns onto the walls like those of Victorian wallpaper, and the oblique light of morning or late afternoon produced slanting shadow shapes reminiscent of axonometric projections.

I observed and recorded the dense shade beneath the plane trees that formed a centrepiece to so many Greek village squares, the cast shadow often as dark as the underside of the foliage itself. Coffee-drinking locals would appear as enigmatic silhouettes within this shadow, even on the brightest of days. Great eucalypts, less

closely leafed, gave a mottled shade to the ground, whilst waterside tamarisks with their feathery foliage offered a softer-edged shadow.

I noticed how on hot, sharply lit days the sky changed from a pale yellow on the horizon through to intense blue-violet above, becoming deeper in colour before noon. Unless I looked straight into the sun, the roofs and white lime-washed buildings showed lighter than the dense sky. Doors and windows were deeply shadowed. The distant mountains appeared a transparent green-blue, palely echoing the cast shadows nearer to hand. I realised that, if this sense of brilliant lightness is to be achieved in a painting, the painter must understand the

(Above) *Tonal study of courtyard shadows*

(Below) *Tonal study of café chairs underneath trees*

extended tonal range required, from intense darks, through well-differentiated middle tones, to precisely placed light passages, which contrast sharply with the surrounding darks.

The difficulty often experienced by painters in capturing this light, with its internal reflections, lies in attempting to absorb extreme darks such as doorways, windows and tree shadows into the composition as a whole. An understanding of the middle tones will be vital here, since these provide linking passages between pictorial elements that might otherwise appear too harshly juxtaposed. Before starting to paint, I like to rehearse my tonal range with a number of small monochrome studies, simply to tune my eye to the specific quality of Greek light. These studies are also useful to me in recording the effects of light on a subject at a particular time, providing me with a handy reference to show changes in light during the course of the painting. There are few more sure ways of courting disaster than to attempt to change a painting constantly as the sun moves round.

Now comes the question of colour – that element in my painting that develops as I attempt to build up the tonal structure I have established in my mind's eye through my studies. Perhaps I'll be making a picture of one of those delightful Greek front yards, its tiny outdoor living space bounded by white walls, furnished with a table, a chair and old olive-oil cans filled with flowers. The

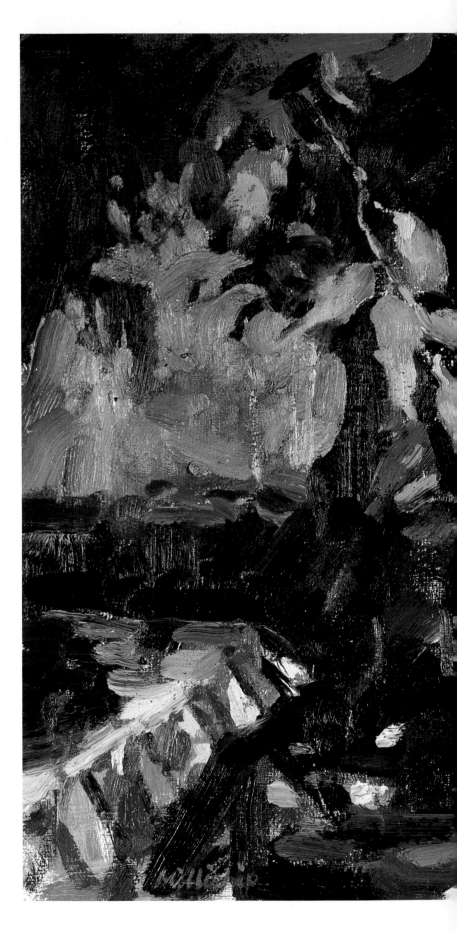

Village Front Yard

Worked directly onto the board, this painting was built around a structure of blues and violets, placed to define the darks. Areas of bright colour were put in first and the deepest darks added with pure Alizarin Crimson.

When the painting was dry I added some dark-blue glazes to reduce the small background areas in tone. Oil on board, 36 × 51 cm. (14 × 20 in.)

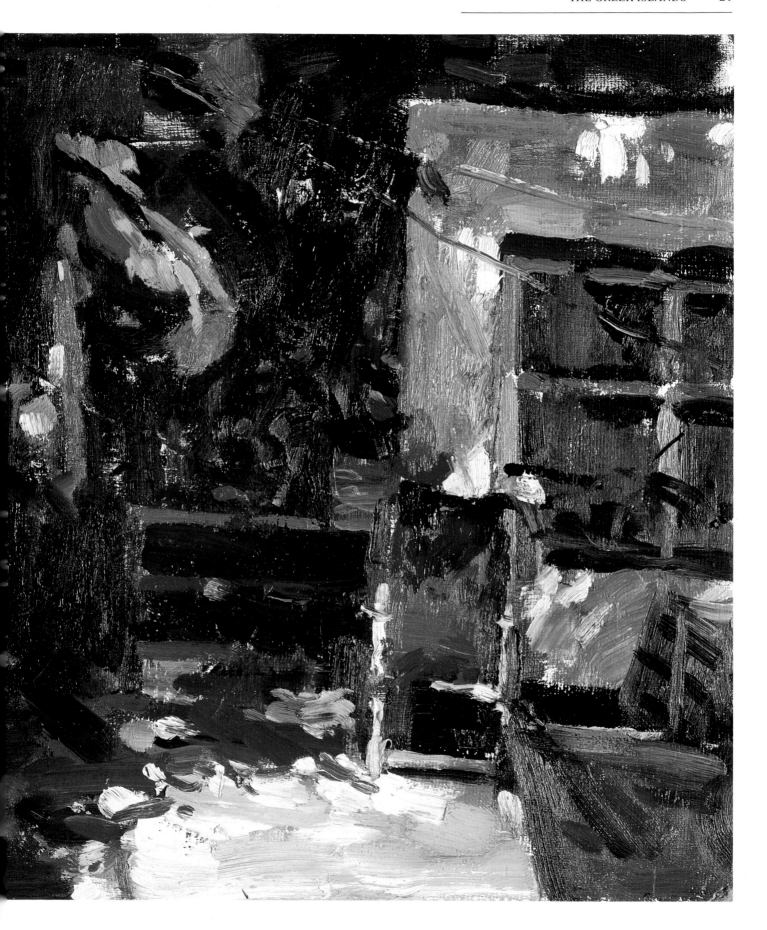

*Pencil study of a
shattered column*

pattern and mood without losing the unity of the painting. A slowing of the working pace may well be a good idea, allowing plenty of time for a comparison of painting with subject, and, perhaps, to reflect on the reasons why I chose this particular subject in the first place! As the work progresses I begin to introduce those dark accents that give definition and depth, integrating them into the pattern of the painting as a whole. I like to create these accents in rich colour because this is the key to the brilliant sunlight of Greece. Any relapse into greys, browns or blacks for darks will immediately lower the temperature and tension of the picture.

An advantage to working in Greece is that the likelihood of settled weather from early spring through to autumn means that I can return to my motif for several days running if necessary. Shadows can move fast in the morning, however, as the sun rises, so two or three hours at a time on one motif is probably enough. I would never attempt to work on the same picture on site through a whole day.

During many and regular visits to Greece I came to appreciate more and more the part which the clear light must have played in the vision of its artists – how satisfying it must have been for sculptors of the classical era to know that every touch and turn of the chisel could be made to register the smallest detail of a carved figure or a decorated urn. The sunlight of Greece brings every form to life, revealing the wood grain on a dilapidated door, the minutest crevices in a lime-washed wall, allotting to each tiny shadow its due portion of warm reflected light.

On the island of Skiathos we travelled by boat to Lalaria Beach, which is composed of smooth marble pebbles of eye-hurting whiteness. The reflection upward from these stones was powerful enough to make the beach scene look like some drama lit from below by stage footlights, and I was very aware of how

Study of Moored Boats, Sigri

The solid forms of white-painted boats can appear to have their surfaces broken down by refraction created by the intense light on the moving surface of the water. For this quick study I used a little masking fluid to show the general direction of the refracted moving shapes. Masking fluid gives a crisp edge when it is removed. After the added washes are dry, this edge can be a useful way of rendering the sharp qualities of Greek light. The dark foreground reflections were intensified with Winsor Blue and Alizarin Crimson to provide a further contrast with the sunlit areas. Watercolour, 37 × 21 cm. (14 × 10 in.)

whole area might be shaded by a vine casting dappled shadows: a simple and common-enough subject lent patterned richness and complexity by the intense sunlight. Whatever medium I choose to render this subject, my first aim will be to establish the broadest possible area of a middle colour/tone on my canvas or paper. That blue-violet shadow which may envelop two-thirds of the courtyard can be mixed and placed according to the medium to hand, maybe in a transparent watercolour wash or as a thin film of paint or perhaps a fine scrubbing of pastel. I now have a co-ordinating, dominating colour, which will act as a ground into which the shapes of doors, chairs, vine trunks and other dark-toned elements can be placed. The overall pattern should begin to emerge at this stage.

My concern will now be to develop that

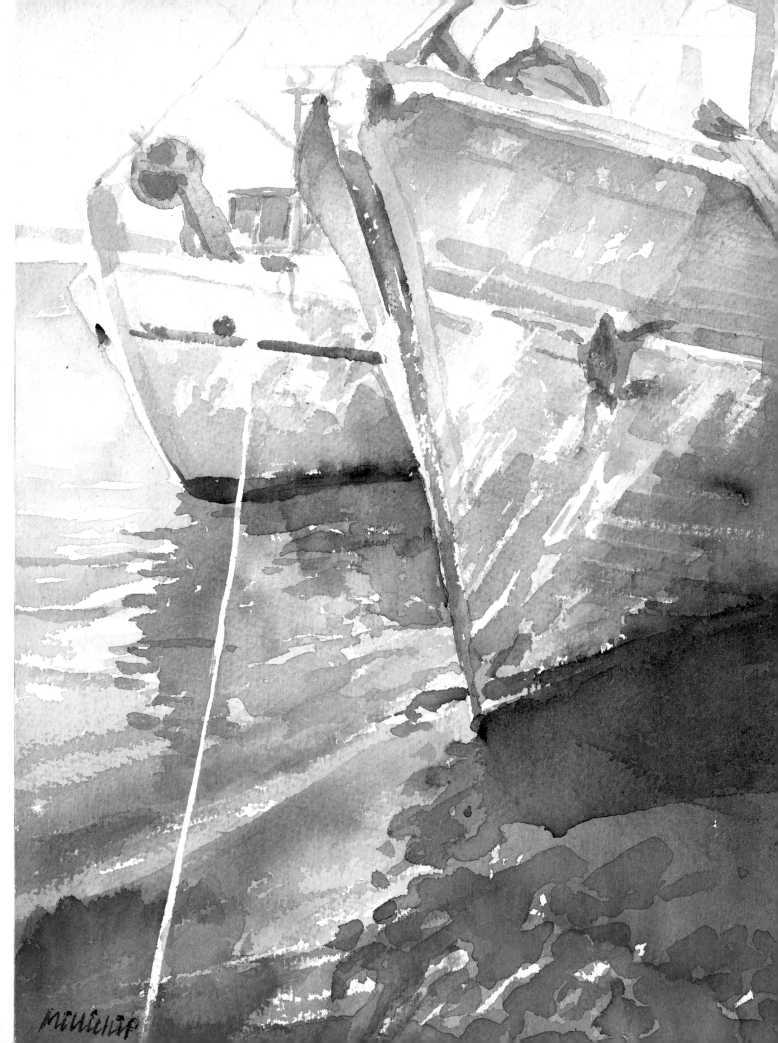

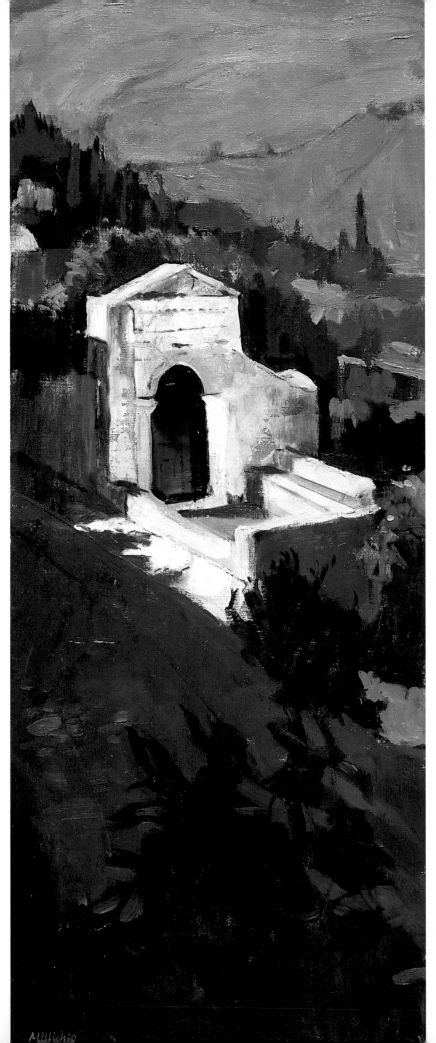

light reflecting upward onto the statues and bas-reliefs in Greek temples must have added immeasurably to their dramatic effect.

On Skiathos, as on other islands, I saw a number of chapels. Possibly more than to any other subject in Greece, I have always felt attracted to those tiny white buildings, which are found everywhere. Made to honour a family member or a favourite saint, they are lime-washed and stand out brilliantly amongst their surroundings. When they are set on some rocky promontory against the sea, these chapels glow with an intensity which calls for all the painter's skill and concentration in rendering. Certainly the initial tonal rehearsal will prove very useful here.

The coast of Greece and its islands is rugged and heavily indented with many bays, coves and natural harbours. This coastline has an obvious attraction for painters, with its fascinating interchange of rock and cliff, white sand and clear sea. Looking across one of these bays on a day of sunshine, every minute detail of landscape, perhaps over a mile away, stands out precisely in the clear light. The clarity is of course equalled in the foreground, and this presents a special problem for the painter, who has no intervening dust or atmosphere, as in, say, Morocco, to imply aerial perspective and spatial relationships. As always in painting there is no single solution to this problem, although the question of *scale*

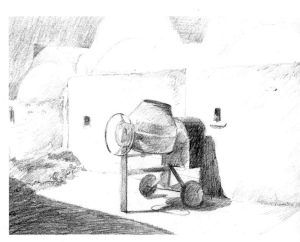

(Far left) **Pillared Door and Courtyard, Lindos**

Brilliant midday sun spotlit this doorway amongst deep shadows. Light was reflected upward from a paved courtyard. The central area was worked with glazes over a white underpainting, whilst direct painting was used for the remainder. Oil on canvas, 102 × 38 cm. (40 × 15 in.)

(Right) **Chorio Door**

There was a great deal of reflected light around in Symi upper town on the morning I made this painting. The battered doors absorbed light in all their crevices and the lime-washed wall seemed to glow as the light bounced up from the ground. A mixture of French Ultramarine and Cadmium Red helped to register the shadows, and I added further washes to obtain the maximum contrast with the light coming round the edge of the door. A pointed brush was useful for the door carving, but I kept the paint very fluid. Watercolour, 56 × 38 cm. (22 × 15 in.)

(Left) Intense sunlight gave a sculptural quality to this battered cement mixer and to the chapels, both potent symbols of present-day Greece.

Chapel and Sea

The sharp shadows created by the clear light of Greece are especially strong yet transparent on lime-washed buildings near the sea. Where the building is set against the backdrop of the sea, as is this Skopelos chapel, the shadow colour can become almost indistinguishable from that of the sky or water. It seemed appropriate to base this painting on a blue monochrome but I applied some masking fluid first, using a hog-hair brush, to imply the rough lime-washed walls and roof tiles. A further wash of Winsor Blue intensified the sea, and I added a little dilute Alizarin Crimson for the shoreline area. Warm light was reflected up into the shadows from the sunlit steps, and for this I used Yellow Ochre mixed with a little Winsor Yellow, floated on with a soft brush when the blues were quite dry. Watercolour, 36 × 54 cm. (14 × 21 in.)

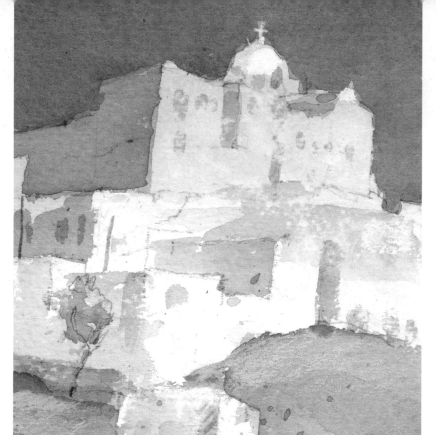

Astypalaea, Chora (detail)

I deliberately placed the church near the top of the picture to suggest its dramatic domination of the town. The shadowed sides of the buildings show my initial blue wash; an extra wash over the sky, with a little added crimson, helped to intensify the silhouette. The colour of the grass at the bottom of this detail was achieved with transparent Winsor Yellow over the blue underpainting.

Astypalaea, Chora

This was painted from a balcony in the late afternoon. Mountains behind the town threw a shadow over the lower buildings, leaving the upper town spotlit against the brilliant sky. I established the hill-top silhouette by careful drawing and used this shape as a guide to place the buildings below. An initial wash of blue indicated the main shapes of sky and hillside, with white paper for light sides of buildings. Watercolour, 52 × 34 cm. (20 × 13 in.)

will be worth considering, perhaps with a degree of simplification, especially for the more distant areas. A related problem I have encountered in Greece, in particular when looking at a subject close at hand, is that brilliant light can show up texture and surface so acutely that there is a risk of burying pictorial structure under an excess of fussy information. However, I do find that the clarity which bright sunlight imposes can also be very positive as a means of developing a strong design in a painting; those sharp-edged shadows and clear contrasts can be usefully related to the picture's rectangle, emphasising the abstract compositional element.

The isles of Greece are many and varied, from the wooded hills of Corfu and the equally lush vegetation of Samos to the barer slopes of Thira or Astypalaea, but running through them is the special character of the Greek landscape, with rock and stone never far below the surface. Despite the coming of air travel, the sea is still the important link between islands. We were made aware of this yet again recently when our ferry was delayed for five hours because an entire

circus had to be loaded on board at a previous port of call!

I have spent some of my most enjoyable days drawing and painting in Greece, sitting on a harbour wall and recording the activity of fishermen, sketching an impromptu sirtaki dance in a country taverna, sheltering from the sun in an olive grove whilst drawing the contorted trunks of the ancient trees. Always for me the unifying element has been that clear light, with the uplifting and transforming power which must be a delight, albeit a challenging delight, for any painter.

Loitering on a Greek quayside and appraising the various moored boats, I saw one displaying a notice that neatly summed up my feelings about Greek-island light. The boat was a pleasure cruiser called *Metamorphosis* and ran daily to other local islands – 'Metamorphosis every day' said the sign. For me, the light of the Greek Islands delivers just that, not merely illuminating but changing what could be considered commonplace into something more intense and magical and, above all, paintable.

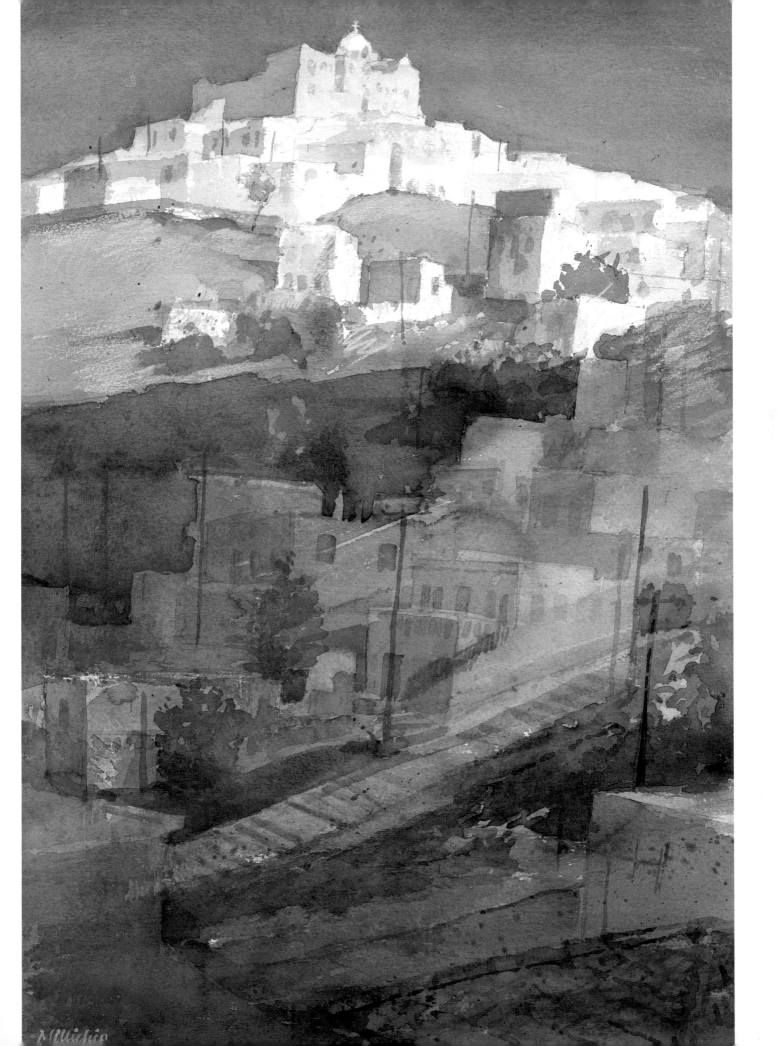

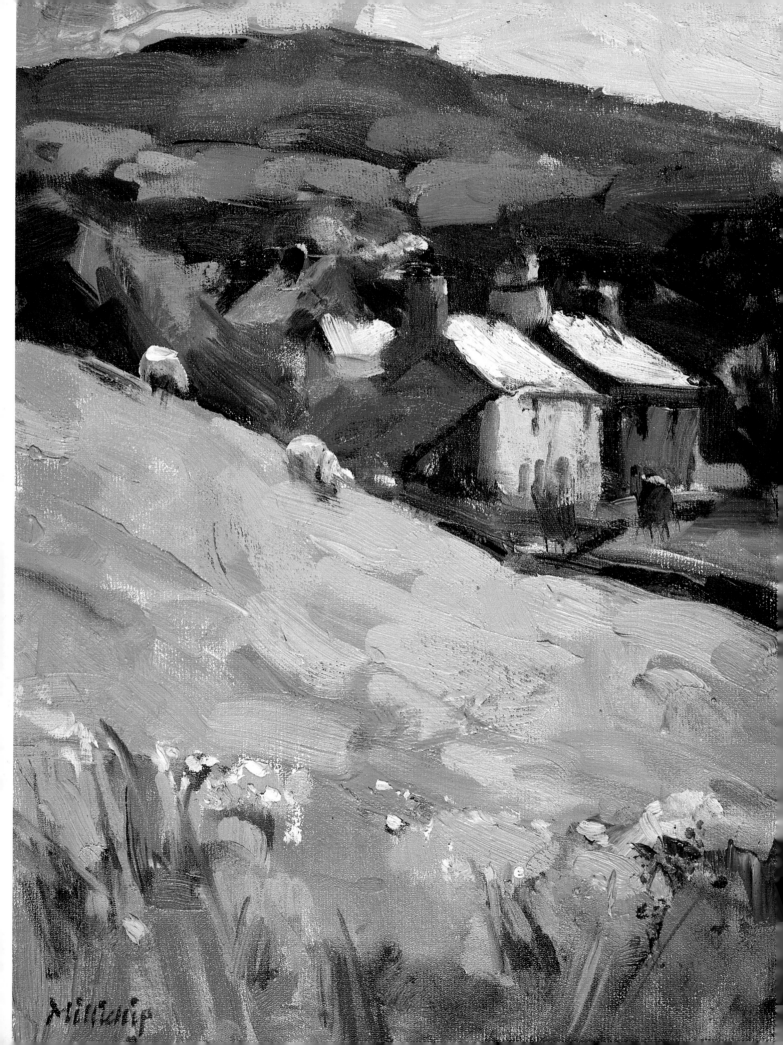

THE LIGHT OF WALES

Mountainside near Blaenau Ffestiniog

A small study attempting to catch the quality of light on an afternoon of sun and cloud near this slate-mining valley town. Slate roofs with their shallow pitch reflect the light in dramatic fashion, while the intense blue in the mountainside is increased in bright sun. Little reflected light in the shadows means that the shadowed sides of buildings are almost lost against the background. The first placing of compositional shapes and proportions was made direct onto the board, using French Ultramarine diluted with turpentine. The brilliant green grass in the foreground was made by mixing Winsor Blue into Winsor Yellow. This yellowish mixture was used as a complementary against the blue-green of the distance. Brush strokes followed the hillside contours. Light impasted areas on the roof went in last, together with a smudge of chimney smoke. Oil on board, 36 × 26 cm. (14 × 10 in.)

(Right) Detail of roof tops against the mountainside, showing brushwork.

The young woman looked me straight in the eye. 'Course, I'm not stripping off, or anything like that,' she said. Mutinous grumblings sounded from my group of students, pencils poised for a preliminary life study. I had been invited to this college in mid-Wales to tutor a weekend of figure painting. The model originally hired had gone sick and here was her substitute refusing to pose nude! I heard mutterings – '. . . booked under false pretences' and '. . . demand our money back' – from the group. Gallantly a college tutor's wife volunteered to strip off instead. 'Could have been a nasty situation there, Mr Millichip,' murmured the Principal in my ear. Our two models now grouped themselves in a somewhat bizarre death-bed tableau: a robust reclining nude and a severe, fully clothed attendant, who was reading whilst keeping vigil at the bedside. The juxtaposition somehow epitomised Wales for me, a land of unexpected contrasts!

After a weekend of teaching I set out to explore again some of this magical country, which I had last visited in my youth, and to rekindle a love too long neglected. Here in Wales I rediscovered the grass that is greener on both sides of the fence; the trees that range from hawthorns angled crazily away from the prevailing wind, to semi-tropical growths in cloistered coves; a rugged yet field-bordered coastline that is possibly amongst the most beautiful in Europe, complemented by hill, moorland and mountain, with variety and drama enough to thrill any painter. No wonder that Turner was only one of a long line of

In the Preseli Hills

I sheltered from wind and rain in the lee of a stone wall to work on this watercolour. The diagonal of the racing clouds was opposed by the line of the hill; a diagonal is always a good way of implying movement. Sweeping strokes of a large house-painter's brush filled with a mixture of Winsor Yellow, Yellow Ochre and Winsor Blue established a sense of wind blowing across the hill. When this wash was nearly dry I swept a similar mixture, this time with some Cadmium Red added, across the foreground. Ultramarine, Alizarin Crimson and a little yellow established the cloud colour. The painting was completed under shelter and from memory. Watercolour, 28 × 52 cm. (11 × 20 in.)

(pp. 34–5) From Y Felin

This was a day when hazy spring light implied a continuum of space across the fields and sea to an indistinct horizon. I mixed a range of pale greens from Winsor Yellow and Ultramarine, with some Yellow Ochre added, especially for foreground areas. Some Alizarin was used for accenting bushes in the foreground, and a little Cadmium Red for the clouds. Watercolour, 38 × 53 cm. (15 × 21 in.)

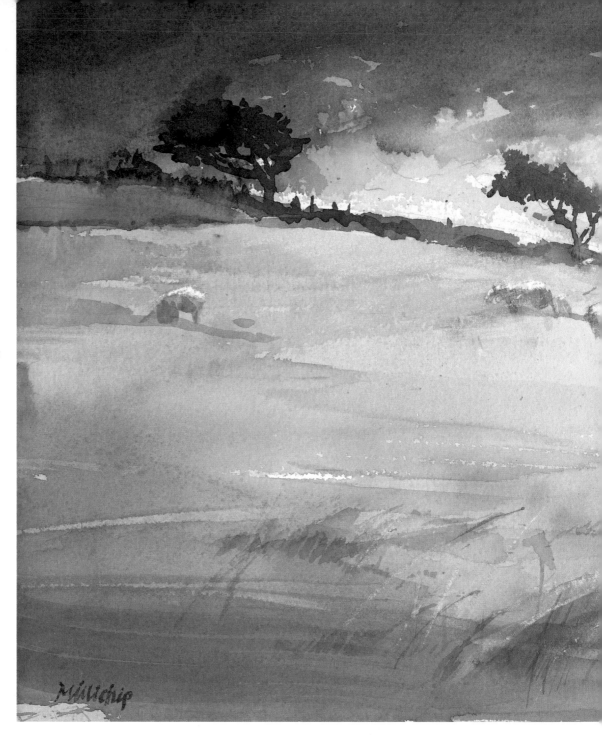

artists to paint in the Principality.

On the coast, westerly winds bring impressive, ever-changing skies together with light that can show as a flash of steel over the sea, or a spotlight on a whitewashed farmhouse, or as sun filtering through a stately progression of clouds, with attendant shadows, across the mountains.

Various tutoring assignments started me on a series of regular visits to Wales, at first mainly to Pembrokeshire. This coastal area has long been popular with painters, with its intimate fields, standing stones and dark skies, pointing up the menace that can underlie natural forms. Painters working here may well feel the need to catch that moment when the constantly changing light matches the mood of their subject – when the diagonals of racing clouds are set against the line of a wind-blown thorn bush, or when the sun momentarily strikes a lichened rock.

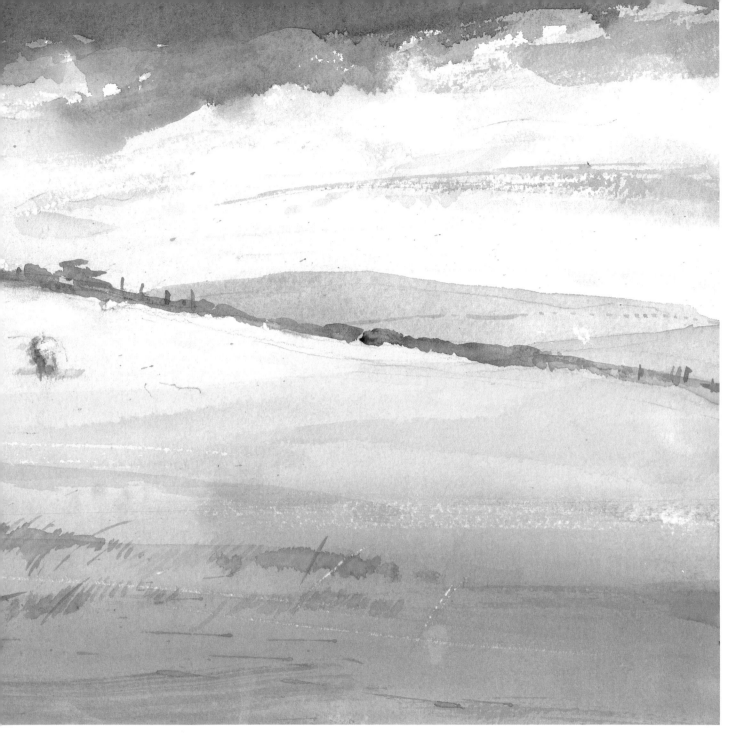

To walk the coastal path which runs along miles of cliffs and beach in Pembrokeshire is an ideal way of experiencing the many different qualities of light in this part of Wales. On a fine day the sea-cleansed sunlight can offer a clarity and transparency that is almost Mediterranean. Blades of cliff-edge grass show in precise detail and distant Strumble Head Lighthouse appears startlingly white against the slaty, blue-grey sea.

In late afternoon long violet shadows are cast across the cliff-top pastures, defining the contours of the land as a prelude to a cloud-barred and theatrical sunset. This is the landscape, so well known in the painting of Graham Sutherland and John Piper, which had such a profound influence on post-war British romantic painting. In the fading afternoon light the woods adjoining the beach near St Ishmaels can take on a mystery that recalls Sutherland's

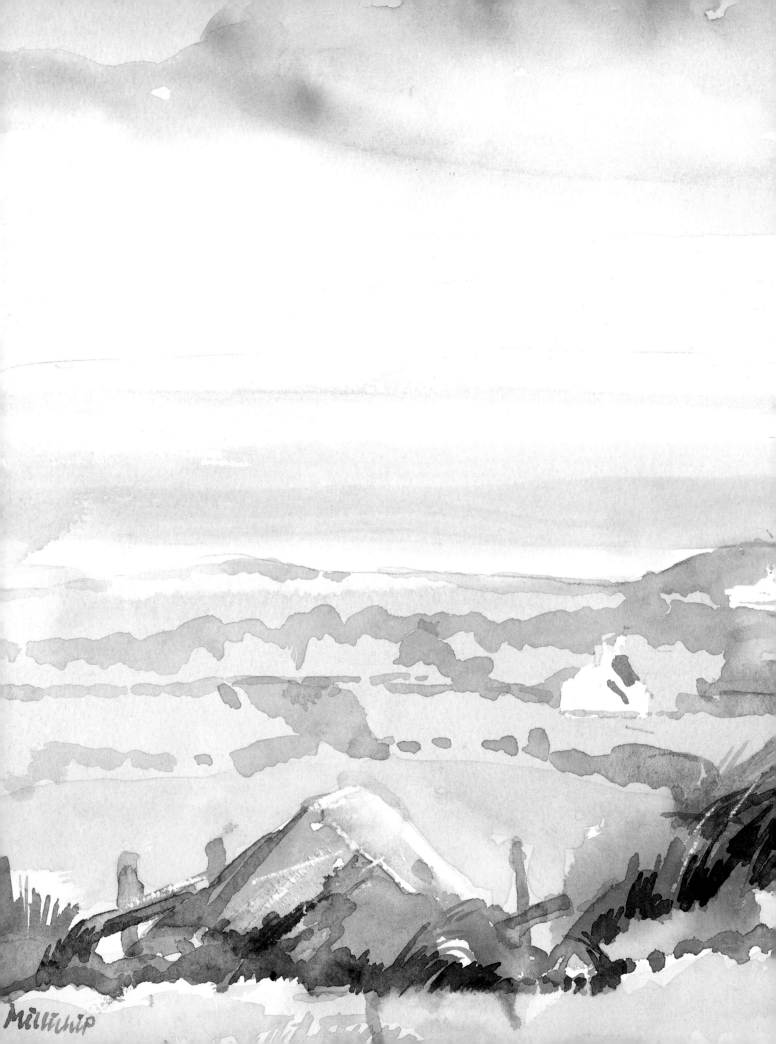

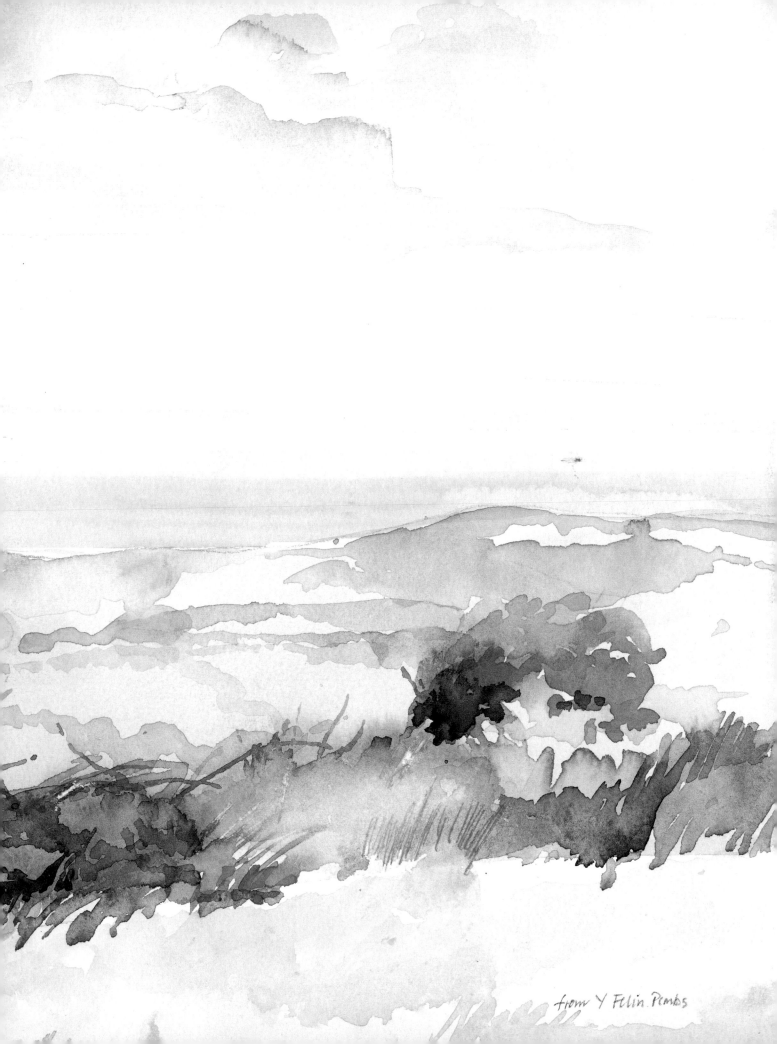

from Y Felin. Pembs

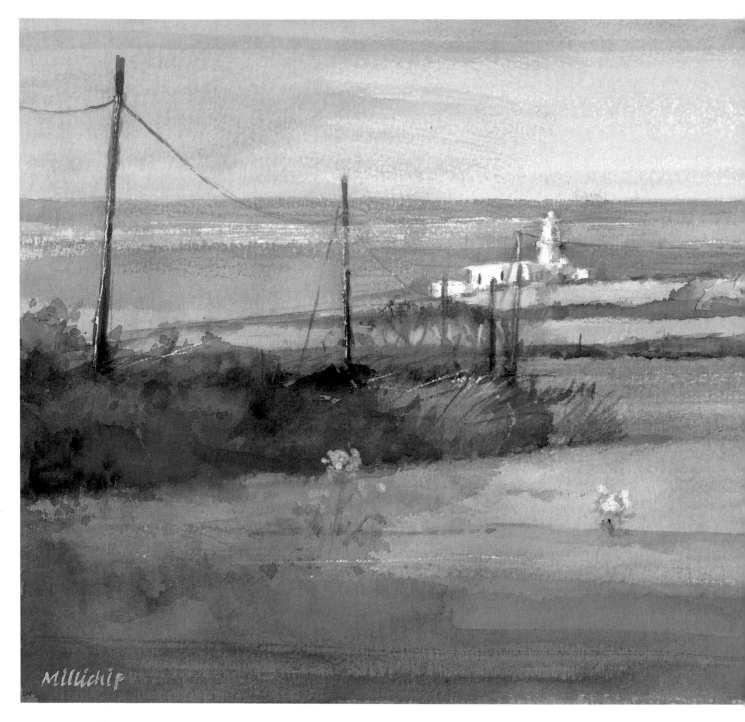

Millichip

shadowed and tortured forms, and the haunted contact with nature achieved in his best work.

Further north along this coast there are plenty of rocky and sandy coves, each one with a character, colour and atmosphere of its own, depending on its orientation, the formation and colour of the rocks, and the way those rocks absorb or reflect the light. Marloes Beach, with its great fractured buttresses of glittering granite, has a sculptural quality that enfolds and dwarfs the people who come there. I have sat and painted on this beach as the rocks seemed to hover in the heat-haze of a summer afternoon, and have drawn those same diagonal rocks on a grey day when their great spiky shapes are silhouetted against the sky.

One summer afternoon on the small

Strumble Head Lighthouse

On a warm, late-summer morning, light cloud shadows follow each other across the Pembrokeshire fields, constantly changing the tonal and colour relationship between sea, sky and foreground. I chose a moment when the lighthouse and an adjoining sheep-covered hill were in full sun and silhouetted against the sea. An ochre-green wash gave warmth to the sunlit area and grey-blue sea colour was mixed with French Ultramarine, Winsor Blue and Cadmium Red. A pale mixture of Winsor Yellow and Winsor Blue, used sparingly, was pulled across the foreground with a large brush, letting a little paper show through. Foreground shadow was added using the same mixture, plus some Alizarin Crimson. I used a little white in light areas to counteract the slight yellowness of the Arches Rough paper, and this helped to emphasise the lighthouse. Watercolour, 27 × 51 cm. (10½ × 20 in.)

beach of Nolton Haven, while my family played in the water, I sat and noted the nature of the sunlight on green-mossed pink rocks, a lovely colour combination. A little further north the great expanse of Newgale Beach offers a light reflected up from an open, broad stretch of sea-washed pebbles. Continuing round the coast, the small south-facing harbour of Solva, with its tree-lined banks and discarded lime kilns, has a softer, warmer light, whilst beyond, in St Davids, that smallest of cathedral cities, the grey stone houses and the cathedral itself are seen with a clarity to be expected on a sea-girt promontory. By contrast the dark local bricks of Porthgain, some miles further on, absorb the light, and the once-busy and now-ruined industrial buildings surrounding the harbour have a look of

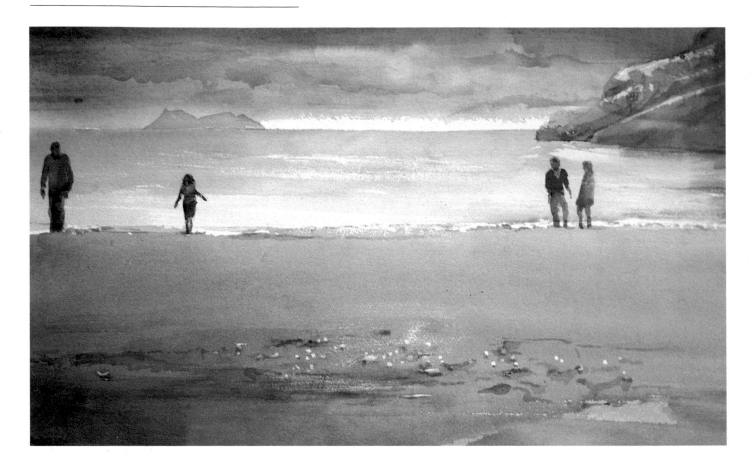

Druidston Beach

The menacing low cloud lent an air of expectancy to this cove in the late afternoon. I mixed Ultramarine and a little Alizarin to make a blue-violet underpainting, establishing the prevailing light and mood. This colour was used in varying strengths for the sea, the cliffs, the sky and the figures. Washes of Yellow Ochre went on over the sand when the underpainting was dry. Yellow Ochre is fairly opaque and needs to be used thinly as a glaze if the colour beneath is to be effective. Watercolour, 51 × 74 cm. (20 × 29 in.)

desolation even on the brightest of days. Plenty of scope for a painter to interpret the mood here!

Beyond is Strumble Head. I have painted often in this area and watched from a cottage window as the *son et lumière* of weather, driven almost invariably by westerly winds, erupts with a constantly changing panoramic performance involving piled clouds, shrieking winds, thunder claps and stabs of lightning – a weather melodrama so thrilling that even painting is suspended! Within minutes such a spectacle may be followed by blue skies, sunshine and the white car ferry from nearby Fishguard ploughing steadily across an ever-calmer sea to Rosslare. Light, mood and weather can change almost instantaneously. Busy Fishguard with its large port and harbour is followed by Newport, which is north-facing and has a special light and atmosphere in its bay. I have sat and painted here and noted how the colours and mood alter as the tide runs in and the

wet mud, sand and beached boats are fast replaced by sky-reflecting water with the same boats afloat – not an easily painted scene, especially when accompanied by a light that acts like the rapid opening and shutting of a Venetian blind. This ever-changing light makes the ideal dramatic complement to the ancient monuments in the region, such as Pentre Yfan, its huge capstone seen to best effect against dark, racing rain clouds, or the eleventh-century Celtic cross nearby at Nevern, its gaunt shape capturing the light filtered through churchyard yews.

The Gwaun Valley follows inland from the north-Pembrokeshire port of Fishguard to the Preseli Hills. The valley is richly wooded and offers deep shade and dappled light, opening out to moorland. Beyond the moorland are the Preseli Hills, rolling and wild, crossed in sun with cloud shadows of intense Prussian Blue. Large standing stones dot the walled fields and can throw impressive and enigmatic shadows across the grass. Painters, who

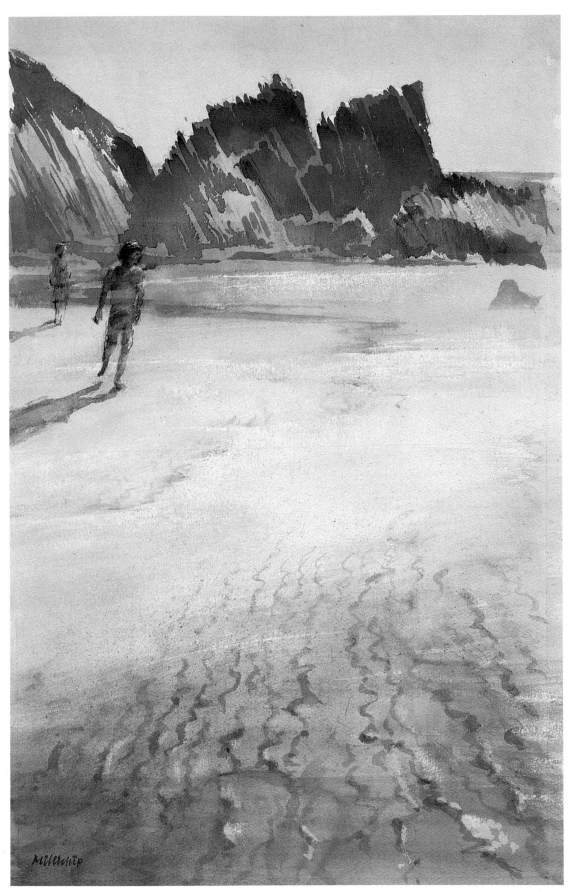

The Beach at Marloes, Summer

A rare hot day on the beach at Marloes, Pembrokeshire, when I tried to capture the quality of heat-haze on the slanting jagged rocks and ribbed sand. I first outlined the silhouette of the rocks and indicated their structure. This shape was then placed in Winsor Blue and allowed to dry. A very fluid mix of Cadmium Red and Winsor Yellow followed, showing rock structure, and shading into pure yellow as I struck the brush across the paper. I used separate dishes of red and yellow for this purpose, gradually letting yellow take over from red and then bringing red in again for the foreground. I sponged the central area lightly while it was still damp to show the glare of the sun, and added figures and sand ripples when this basic wash was dry. A little work with sandpaper over the dry washes helped to indicate light on damp sand. Painted in the studio from drawings and colour notes. Watercolour, 56 × 38 cm. (22 × 15 in.)

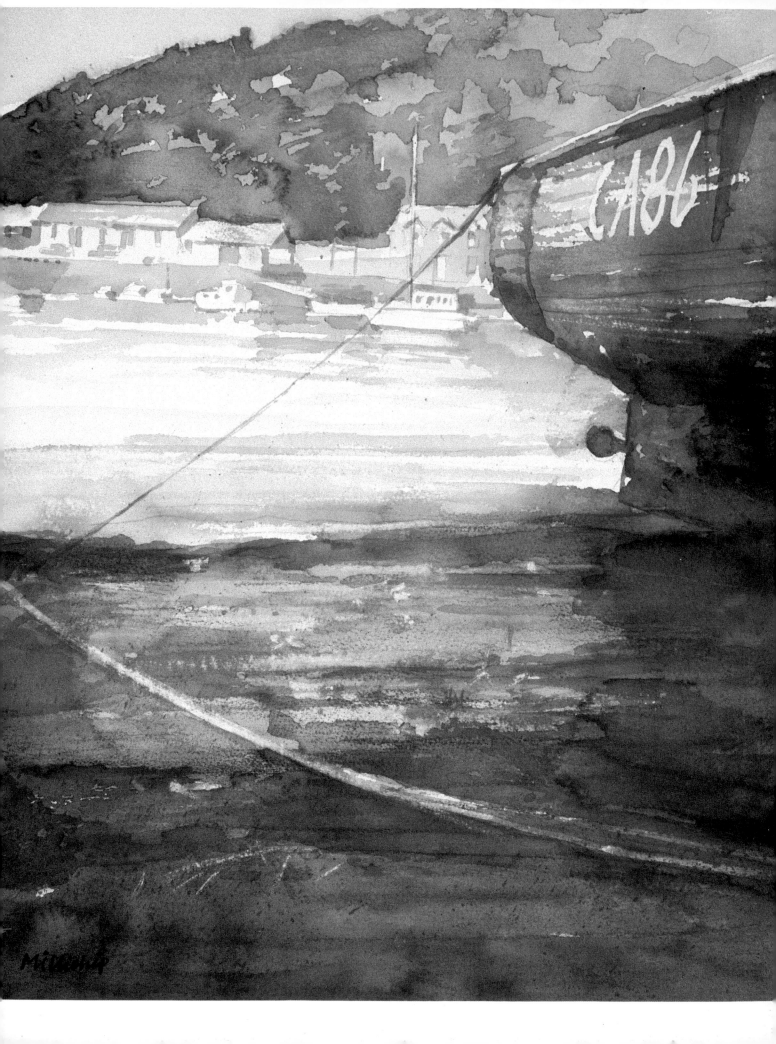

(Left) Fishguard Harbour

Decaying commercial vessels contrast with white pleasure craft, recalling something of the history of this small harbour. Fluid washes of crimson and ochre helped me to establish the sandy and muddy foreground, pointing up the comparison with the pale sunlight on the buildings and boats in the distance. Watercolour, 43 × 35 cm. (17 × 14 in.)

(Right) *Pencil study of Newport Harbour with the tide out*

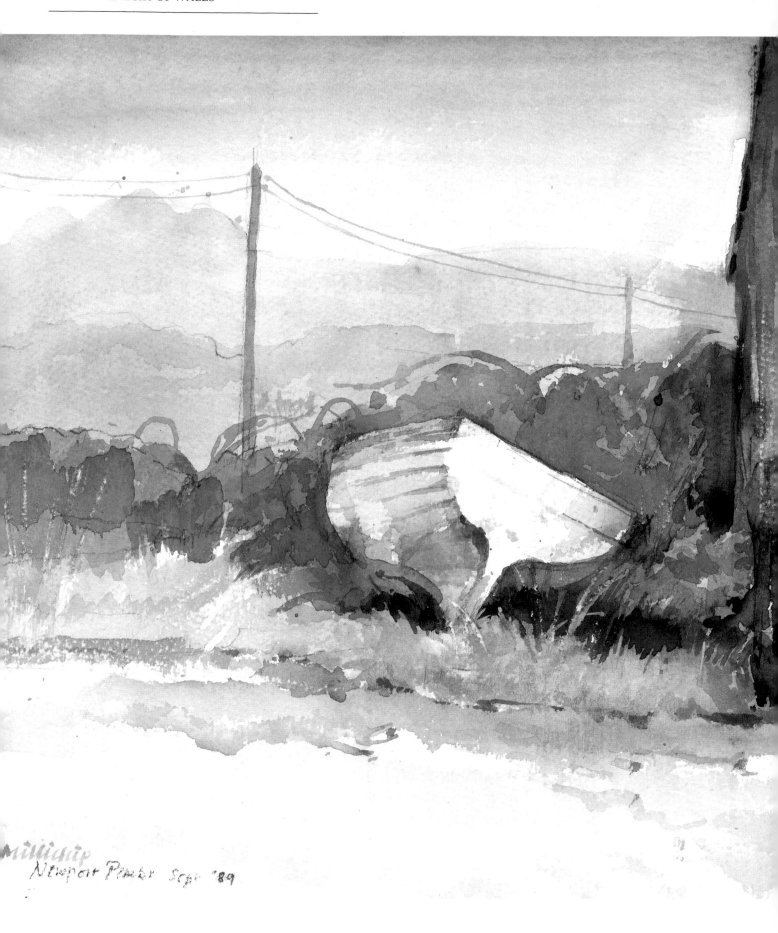

Millichip
Newport Pembs Sept '89

Near Newport Harbour

The rusting lines of a green-painted shed were the attraction here, with local colour showing brilliantly in the rather flat light. A rapid study on a warm but dull late-summer afternoon of diffused sunlight. A green mixed from Yellow Ochre and Ultramarine placed the bushes and formed the shape of the boat and the left-hand side of the shed. Winsor Yellow added to this green established the facing side of the shed, with pure Alizarin Crimson washed thinly for the mud and sand in the foreground.
Watercolour,
30 × 46 cm.
(12 × 18 in.)

never keep to roadways, will want to sample the quality of light and the spare, open nature of the country by walking some of the many footpaths crossing this area. They will find that, on a dull and misty day, the spatial element of this ancient land is emphasised and its mystery enhanced.

I soon realised that painting in Wales meant accepting change as a normal part of the weather. Tutoring a group of painters I decided that we should make the most of the magnificent clouds that had been rolling across from the hills during the last two days, and proposed a cloud-study expedition on higher ground just up the lane from our accommodation. As we set forth the sky began to clear, and by the time we had reached our viewing point it was cloudless! On the following day I proposed a painting trip to a nearby village whose charming whitewashed cottages I had recently seen glowing brilliantly in the morning sun. No sooner had the first washes been placed than a blanket of grey rain descended, adding an extra element of fluidity to the work in progress! West Wales brings out the adaptable as well as the stoical in any painter.

North Wales, harsher, more mountainous, more dramatic, offers the travelling painter a different balance between landscape, colour and light. The Snowdon range dominates the north with

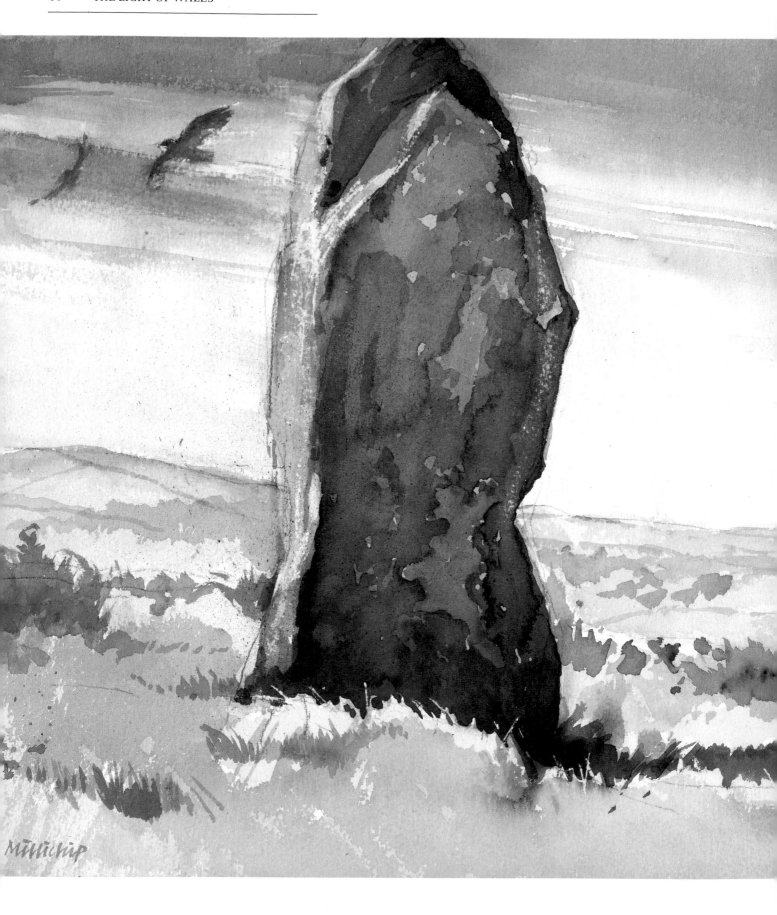

Millichip

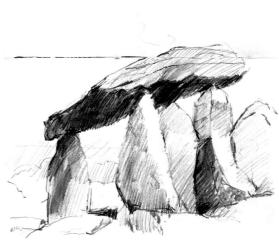

(Left) **Gnomen**

A Pembrokeshire hilltop on a warm summer day. This large standing stone cast a shadow across the fields that shifted slowly with the sun like a huge sundial. A blue wash established the tonality first. Greys for the stone were added using Winsor Blue and Cadmium Red puddled on to suggest the blotchy lichen-covered surface. The diagonal line of clouds and the hovering buzzards were used to imply wind blowing across the hill-tops. A wash of Winsor Yellow over the blue base created greens for the grass and helped to suggest light on the stone. Watercolour, 26 × 36 cm. (10 × 14 in.)

(Above) *Pentre Yfan, sketch-book drawing*

Mountain stream,
North Wales

(Above) *Distant Snowdonia, sketch-book crayon drawing*

(Right) Gwaun Valley

On a perfect late-summer afternoon I set up my easel in a field that gave me a view of the distant Preselis beyond cloud-shadowed fields. An initial underpainting of French Ultramarine thinned with turpentine dried rapidly in the warm air, and I mixed Winsor Yellow with a little Winsor Blue to attempt to achieve the vivid greens of the fields. Lost in concentration, I looked up to see a group of immense black bulls approaching menacingly. It seemed an appropriate moment to pack up my paints and move on, which perhaps prevented the painting from becoming too overworked. Oil on canvas, 41 × 51 cm. (16 × 20 in.)

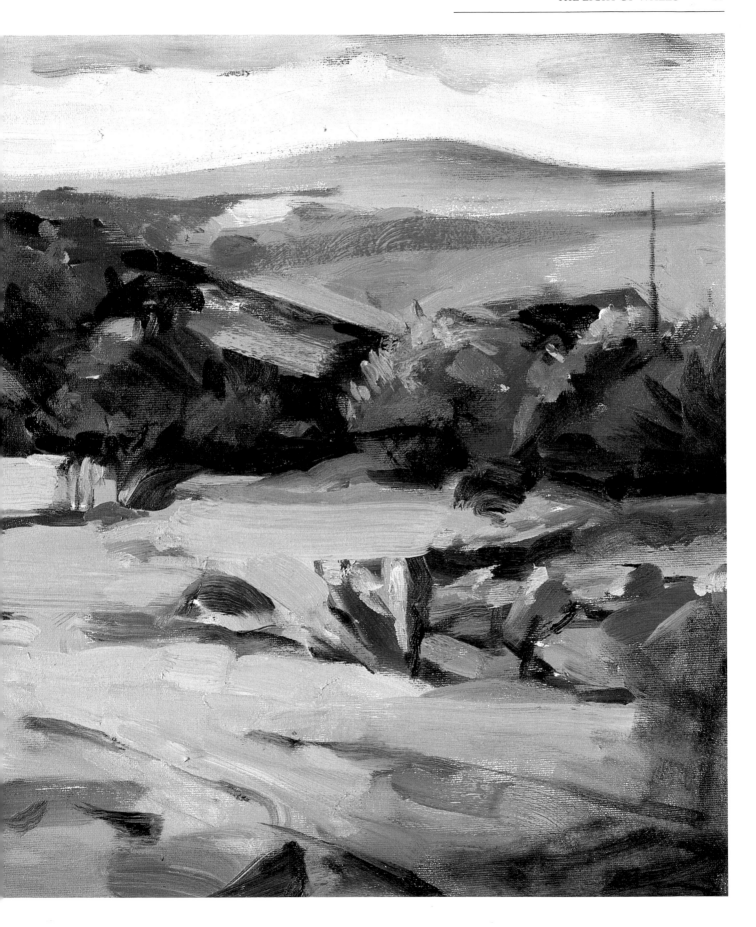

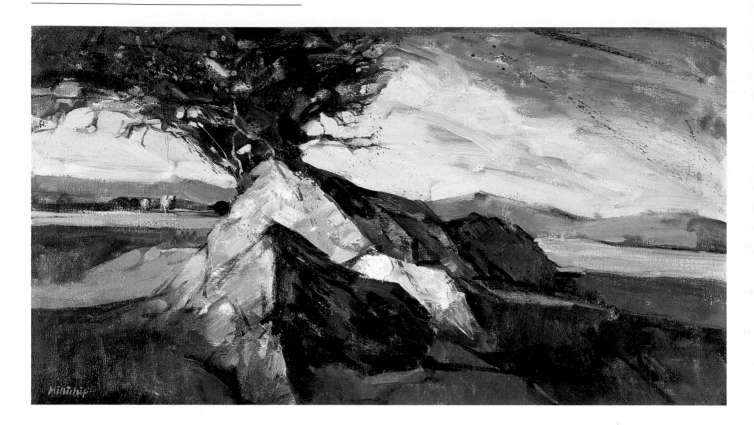

Rock and Hawthorn, North Wales

Low, late-afternoon light illuminated this strong subject, with the split rock echoed in the distant Snowdonia range. I used a knife to build up a solid rock texture in the light foreground passages, while colours were kept thinned for shadows. The fiery red of the berries was applied straight from the tube. I perched precariously on top of an earth bank by a wire fence to make my studies, and my stool collapsed as I finished the last drawing. A suitable valediction! Oil on canvas, 51 × 91 cm. (20 × 36 in.)

spectacular cloud groupings about the peaks, best viewed as a panorama from the island of Anglesey, across the Menai Strait. When the clouds roll in from the north-west, alternately obscuring and revealing the peaks, a theatrical effect is produced as the mountains are seen briefly, lit by the sun, before the purple-grey curtain of cloud is pulled down again. A wonderful subject indeed but a real test for a painter if that light and mood are to be captured.

One of my favourite painting places in southern Snowdonia is Cwm Pennant, a lovely valley which winds northward into the mountains from the Porthmadog–Caernarfon road. Starting as a wooded route with shuttered light through heavy foliage, this valley gradually becomes more open, revealing blue-grey disused slate workings, a walled churchyard and an occasional farm. The stream that waters the valley is crossed and recrossed by the lane, which eventually opens out into a vivid green prospect of broad pastures with mountains beyond. Sheep group picturesquely on the valley floor

while buzzards mew as they hover looking for prey. This pastoral scene is illuminated through gaps in the clouds, the shadows of which reveal the mountain contours: a tantalising subject for painters, who find that, having settled on a pictorial grouping that seems to convey the grandeur of the scene, the light on the mountains changes, the clouds regroup and the foreground shadows assume ever-richer colours. In Wales, change must be accepted as the constant, and a preliminary sketch-book study to establish the composition will be helpful. Firmness of purpose, mixed with just a little serendipity, may be in order here.

Whilst I enjoy viewing the theatrical backdrop of mountains, I am scarcely ever moved to paint them. In North Wales there are many alternatives on offer, including castles, which are almost as frequent as the ubiquitous *ksai* in southern Morocco. In Wales, however, they are stone built and frequently dominate other buildings, as in Criccieth, a charming seaside town a short drive

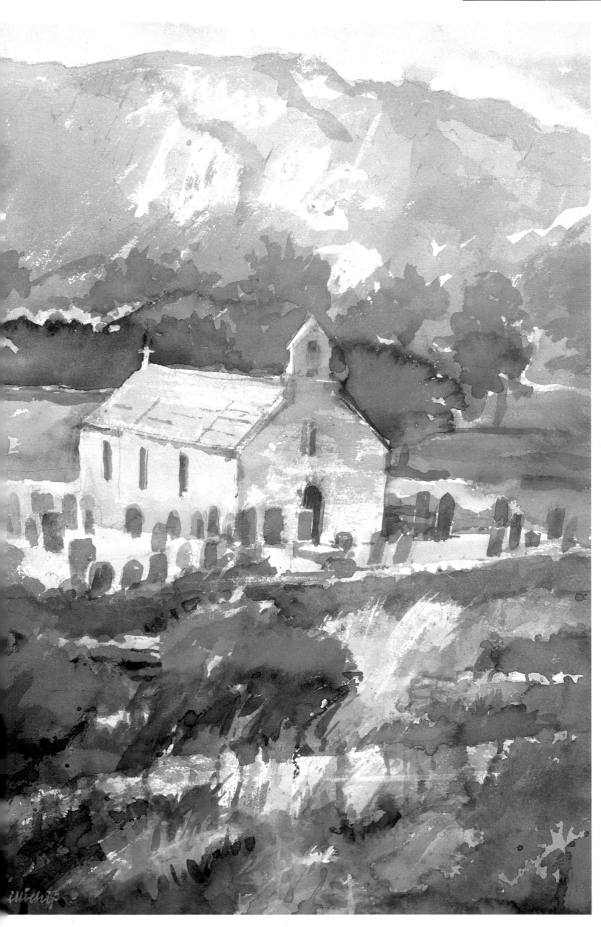

Chapel and Graveyard, Cwm Pennant, North Wales

The essence of rural North Wales seems to me to be summed up in the grey slate and stone of this tiny valley chapel, surrounded by gaunt headstones and backed by the foothills of Snowdonia, with the whole scene lit through occasional gaps in the clouds. An on-site drawing was developed in the studio so that I could relate the drama of the lighting to the mood of the subject. Since the scene was backlit with strong tonal contrasts, I established a blue monochrome base with a mixture of Ultramarine and Winsor Blue. When this underpainting dried I washed a mixture of Winsor Yellow and Yellow Ochre over the areas where greens were required and redefined dark passages with Alizarin and Winsor Blue. A little knife-scraping and sandpapering helped to indicate the texture of stone walls and grass. Watercolour, 53 × 35 cm. (20¾ × 13¾ in.)

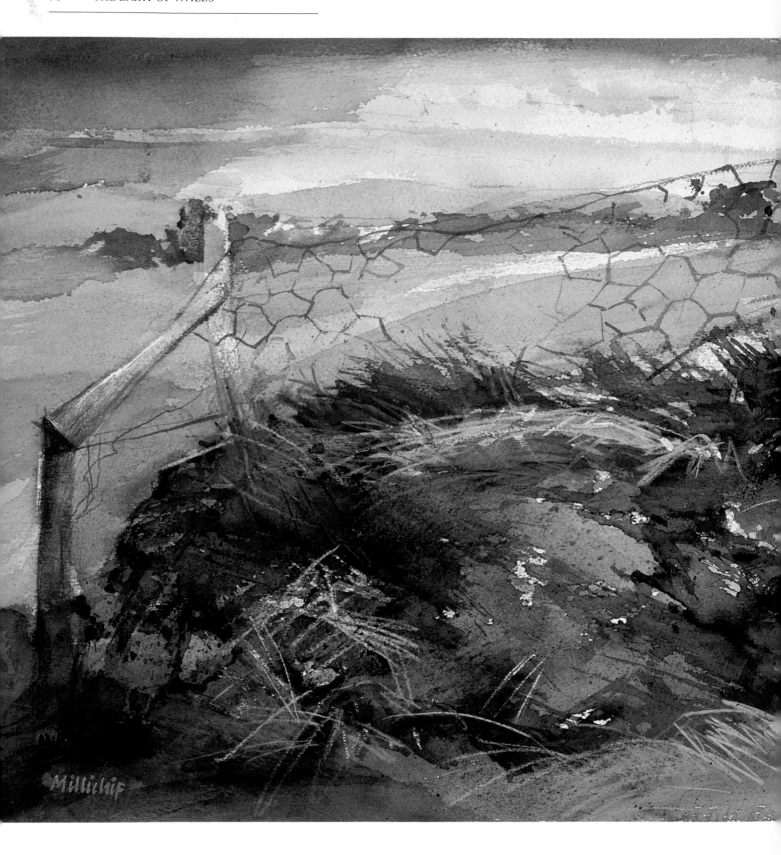

Wall and Fence, Cefn Uchaf

I resisted a first impulse to include sheep, goats and geese in this study as I decided that these would detract from my main interest: the dense texture of this windswept farmyard wall and the way it was affected by constantly changing light. I worked on the painting intermittently for over a week, gradually building layers of paint and crayon to create the density and rhythmic flow of grasses in the wind. The browns of the underlying stone wall were made from a mixture of Cadmium Red, French Ultramarine and Winsor Yellow, whilst the greens of the grasses and fields were swept in broadly with ochre and Ultramarine. Alizarin Crimson was useful mixed with Winsor Blue for the strong dark of heavy vegetation. When this watercolour base was dry I added work with Yellow Ochre and bright yellow crayons to emphasise the direction of the clumps of grass and foliage. Watercolour and crayon, 38 × 70 cm. (15 × 27 in.)

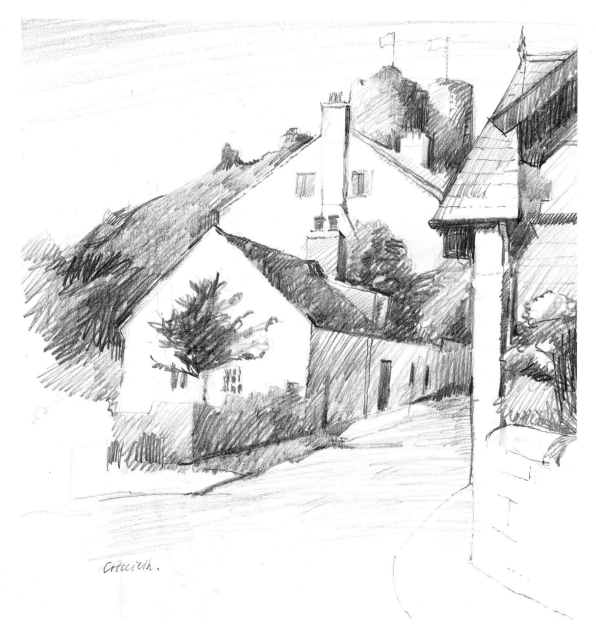

Criccieth.

south of the valley we have just been exploring. Here, the whitewashed terraces reflect the light from the sea, and the green mound upon which Criccieth Castle stands catches the morning sun, silhouetting a ruin which, unlike some Welsh castles, is pleasantly romantic rather than grim. Painters who enjoy exploring the expressive possibilities of different shapes set against the sky will surely delight in this castle with its turrets seen above the roof tops.

During a delightful late-summer afternoon's painting in North Wales, the vivid aquamarine of the distant mountains was matched by the intensity of yellowed grass and lichen-coloured stones in the foreground – what pleasure for a painter! I promised myself that I would return tomorrow, but 'tomorrow' was a flat dull day, with a low ground mist and all colour gone. Irritated by the weather's inconsistency, I took the footpath down to a nearby stream. Here was plenty of light and life and, as I sat and drew, the dull weather seemed to accentuate by contrast the brilliance of the moving water, which coiled and sparkled round stones and reeds. The Snowdonia region is full of such delightful

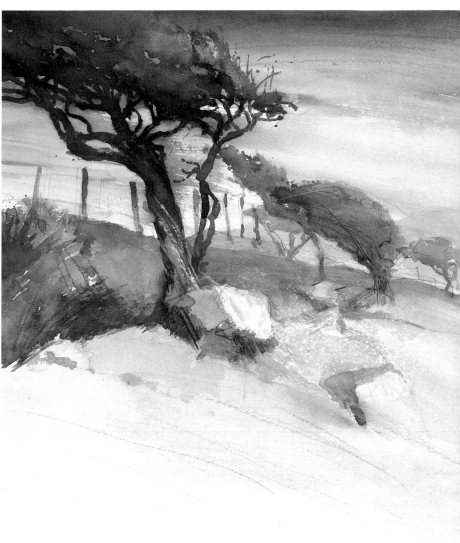

Millichip

streams, reflecting the sky as they flow down from the mountains through fields and trees, over pebbles, round gravel banks, always alive, interesting and presenting alert painters with yet another spritely challenge.

Running nearby, parallel to Cwm Pennant, another valley, Cwmystradllyn, presents bleaker mountain prospects, with the gaunt ruins of a slate-cutting mill standing beside the stream that once powered its machinery. Pursuing my chosen theme of water in movement, I studied the light on the ripples of this peaty stream and enjoyed its bubbling sound as I worked on a painting. I noted the contrast between the ripples and the verticals and diagonals of grasses, reeds and nearby trees. Dominated by water, clouds and wind, the scene was full of ever-changing light and colour.

To paint the landscape of Wales is to work in a region of flux and movement, in which the weather plays an important part in creating a sense of place. The light performs a dynamic transformation on the painter's subject – a very different effect from the feeling of stasis and timelessness lent by the light of Greece. Surely both manifestations can be seen as inspiring and valid by the discriminating travelling painter.

Windswept Hawthorns

An entire row of contorted thorn bushes was situated at the head of this steeply sloping pasture land. I left the foreground completely blank to concentrate interest on the trees. *Pastel and crayon were added to emphasise the diagonal movement. Watercolour, 51 × 33 cm. (20 × 30 in.)*

(Above left) *Detail shown actual size, illustrating the challenge presented to the artist by the wide range of greens in the Welsh countryside.*

Gwaun Valley Stream

Clouds of rain and mist swept along the valley and the forms of hillside, trees and rocks appeared and disappeared as I drew and scribbled notes for this painting, completed in the studio, in which I tried to capture the effects of weather and shifting light. As ever in Wales, patches of grass showed brilliantly green through the rain, and I worked with some yellow crayon over washes to achieve this effect. Splatter-work and sandpaper were used to suggest rain and mist, over flowing washes of Winsor Blue and a little Yellow Ochre. Watercolour and crayon, 34 × 53 cm. (13¼ × 21 in.)

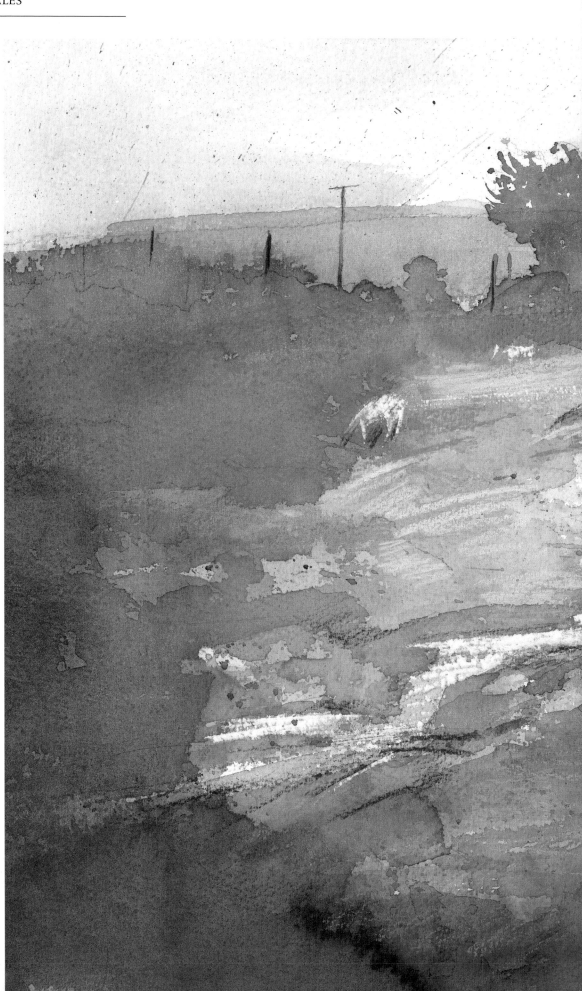

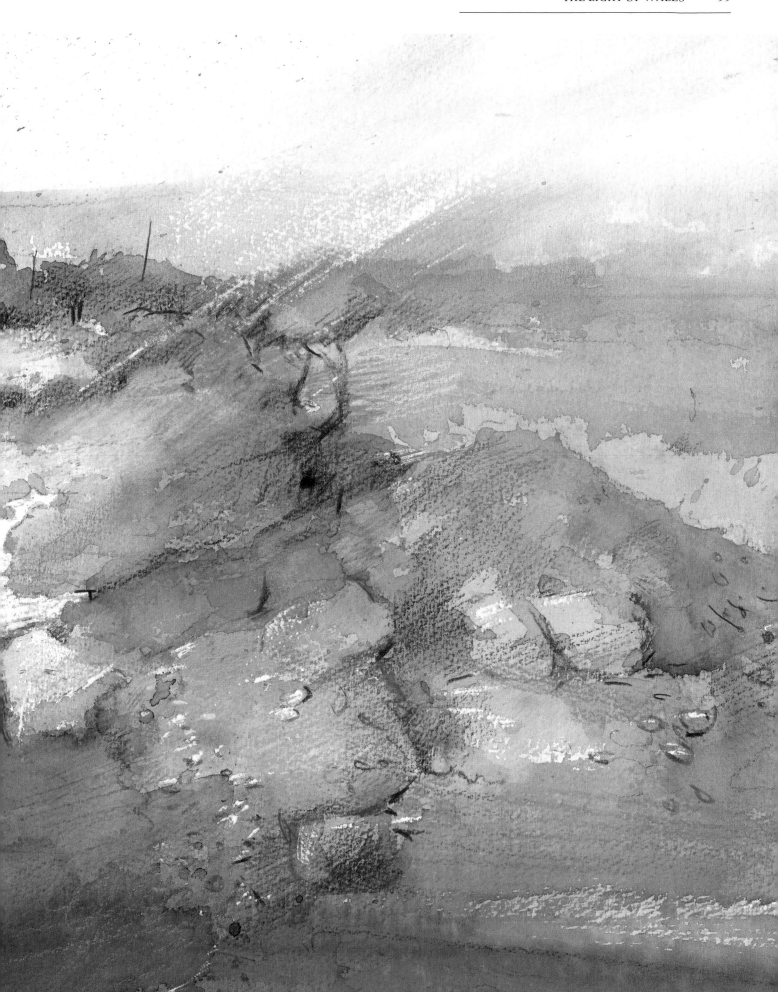

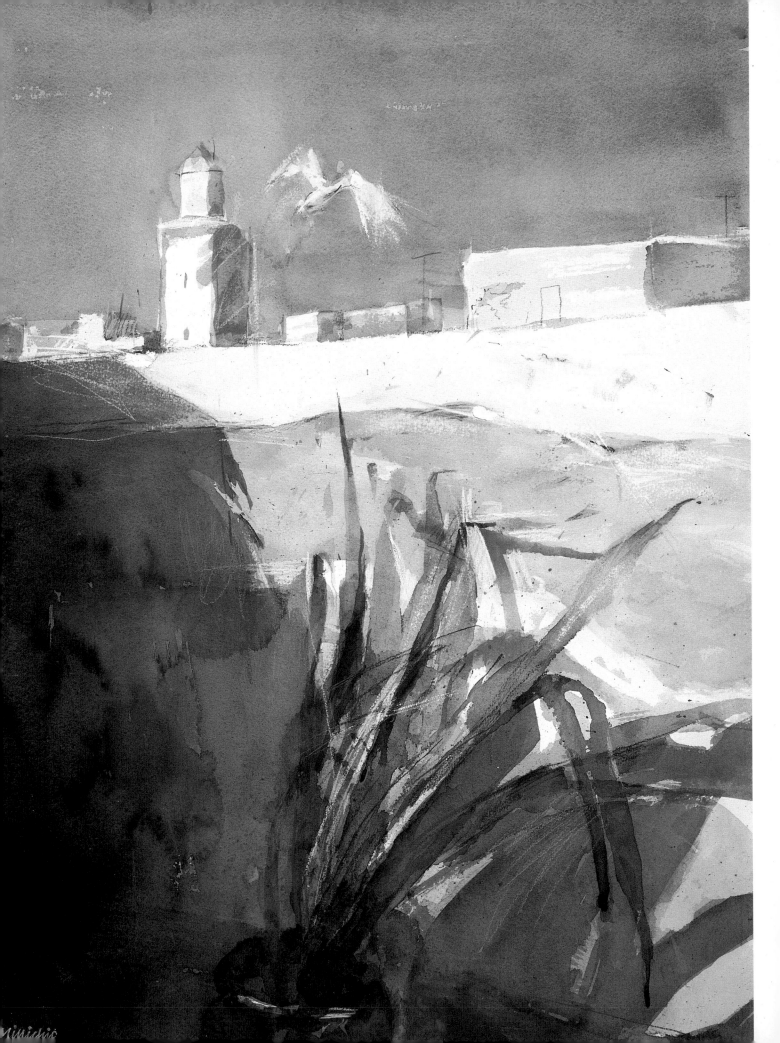

Minichie

SOUTHERN MOROCCO

(Left) From Villa Maroc, Essaouira

On this April morning, brilliant light was reflected off the sea and a violet-tinged sky was answered in strong shadows thrown across the walls of the roof terrace. The tiling gave a pink cast to the undersides of the leaves of a rather straggly potted plant. I used strong washes of Alizarin Crimson over a base of French Ultramarine to achieve the violets, and Winsor Yellow over the blue base for the greens of the plant. Touches of crayon were added for emphasis. Watercolour, 76 × 55 cm. (30 × 21½ in.)

Most painters must have an imaginary land somewhere in their minds, some country full of light and colour and life, where the sights are stimulatingly different and pictures are just asking to be painted. My imaginary land was always Arabian – a North African spectacle with mysterious, robed figures in dusty streets, with pink and ochre buildings, and markets bursting with colour.

Re-reading the great artist Eugène Delacroix's journal of 1832 (written when he was attached to a French diplomatic mission to the Mahgreb), I came to realise that my imagined land was resolving itself into Morocco. Delacroix's record of his journey shows his awareness of the quality of light in North Africa. He writes of a figure 'silhouetted halfway against the door, halfway against the wall, the shadows full of reflections' and another 'bareheaded, very dark, clear cut against the wall, lit by the sun'. These are strong, painters' images and Morocco is a painters' country.

It was after changing planes at Casablanca on my first visit that hints of something different began to appear. Figures in pointed hoods were now amongst the passengers and, glancing across the aisle, I noticed a veiled woman, the backs of whose hands were elaborately decorated with henna. This tiny touch of exoticism was, I felt, a prelude to the sights to come. At Marrakesh Airport a smiling band of local musicians played us through customs.

It takes only a few days in Marrakesh for a painter to establish a sense of the light in this part of Morocco. During the Moroccan spring, from February to April, the sunshine will probably be clear and defining, but modified by the clouds of tawny dust thrown up by people and vehicles. Amongst the key colours are the rose-pink and terracotta of the walls, the ochres of sun-dried mud buildings, the deep blue or crimson, violet, or black and white worn by the robed figures. As ever with such richness, the painter's problem

(Right) Outside the Walls, Taroudant

The dust and warmth of mid-afternoon lent a characteristically North African quality to this study of the tawny mud walls of the town. I used a basic wash of pale ochre with a little Cadmium Red added. Shadows were mixed from Winsor Blue and Alizarin, and washed over when the ochre was dry. Cadmium Red was dropped in occasionally for extra warmth. Watercolour, 36 × 56 cm. (14 × 22 in.)

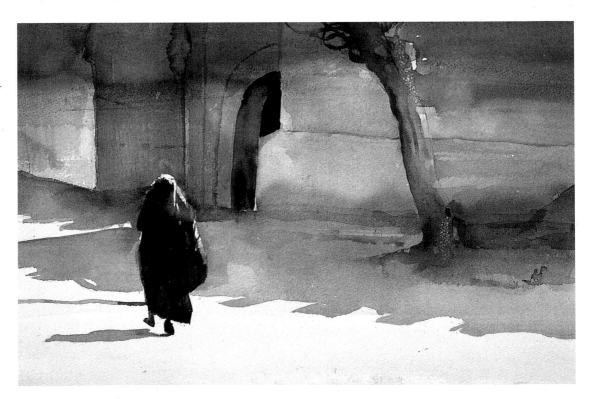

Mountain Market

The peaks of the Anti Atlas Mountains were echoed in the canvas covers of the market stalls, with an occasional burst of fruit colour in the shadows. I built the richest colours I could manage into the darks, using Alizarin Crimson and Winsor Blue. White with Winsor Yellow was used over a bluish ground to express the sunny mountain sky. Oil on canvas, 46 × 76 cm. (18 × 30 in.)

is to know where to begin; having begun, one must keep working despite the intrusions of the curious! In the great central square of Marrakesh, the Djema el Fnaa, it is probably best to order a mint tea and station yourself at a café table on one of the terraces bordering the activity. You can then attempt to appear as unobtrusive as possible whilst trying to capture with a small sketch book the wonders of snake charmers, brilliantly costumed water-sellers, acrobats, musicians – a heady mixture of the unexpected and the unlikely. A sunset drive in a horse-drawn carriage outside the city walls can reveal still more delights. There are fruit markets shadowed in the dusty fading light; mosques with their minarets, from which the cry to the faithful floats across; young boys cartwheeling and somersaulting along at the side of the carriage, shouting for small change.

From Marrakesh an early-morning bus grinds up into those towering High Atlas Mountains, which seem so near when you are in the city but are really some hours' drive away. The rising sun casts long, deep-violet shadows and turns to crimson the *pisé* (mud and straw) walls of the Berber villages en route. Higher up, the light becomes clear and sharp, sculpting the grey-stone tribal buildings which cling perilously to the mountainsides. A small sketch book can be useful here; since the bus grinds so slowly up the mountain road there will probably be time to make a quick note of the buildings or people you pass, using a combination of direct observation and memory, and possibly adding colour from a pocket paint box or with some crayons if there is time. Berber tribal costume is often brilliant in colour, and the morning sun can spotlight a group of travellers waiting, complete with their goats, for the bus to take them on to a market in the next village. To draw the human form is generally more readily acceptable to Muslim Moroccans than is photography,

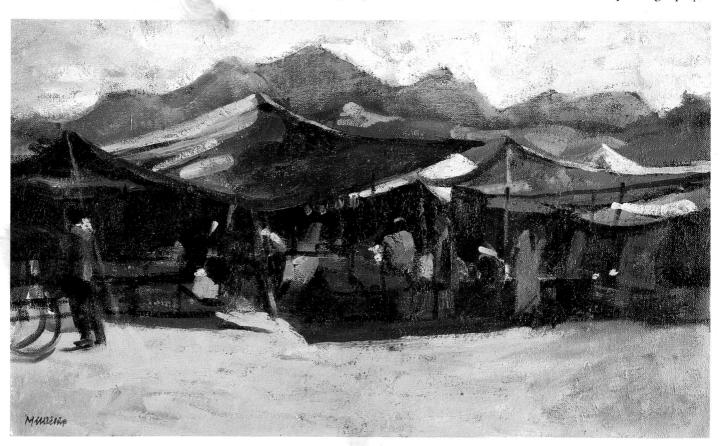

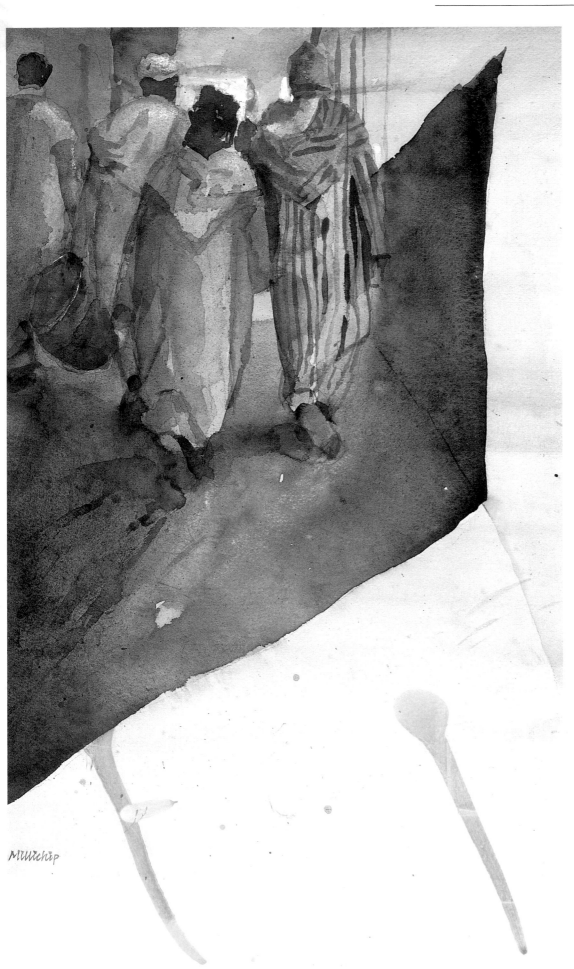

Millichip

Returning from the Souk, Tafraoute

Pink walls lit by intense morning sun gave strong shadows, in and out of which the Berber tribesmen moved. I started by brushing a pale wash of Alizarin Crimson across the paper, and shaded this to Winsor Yellow. When it was dry I drew the shadows and figures in pencil. A rich mixture of Alizarin and Ultramarine created the cast shadow colour, and I dropped some brushfulls of Yellow Ochre into this while it was still wet to imply the reflected warmth. A little judicious sponging lifted up the lighter parts of the figures. To avoid hard edges, the details of the striped djellabas and turbans were added while the shadow wash was still a little damp, and I floated some more Ultramarine into the dark area on the left to intensify the wash. Distant patches of light were added with white body colour. Watercolour, 56 × 38 cm. (22 × 15 in.)

Village Street with Figure

I aimed to capture the purposeful stride of the mountain Berber in this painting, with the angle of the figure's left leg set against the verticals of wall and pole. I created the dusty, bleached colours of the village street using Alizarin and Yellow Ochre, adding washes of Winsor Blue for the fierce midday sky and the strong cast shadows. Watercolour, 76 × 41 cm. (30 × 16 in.)

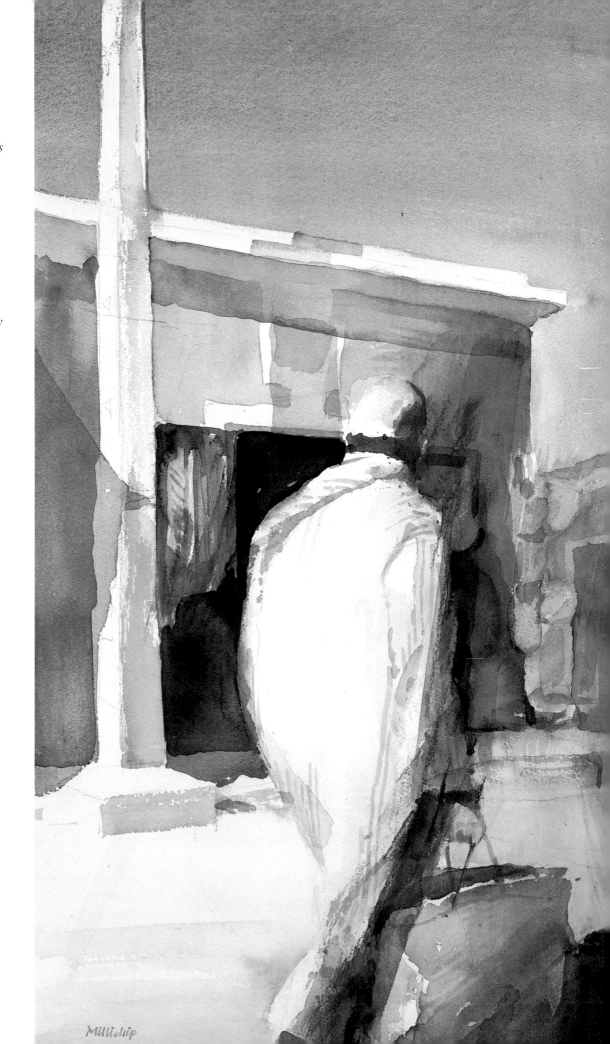

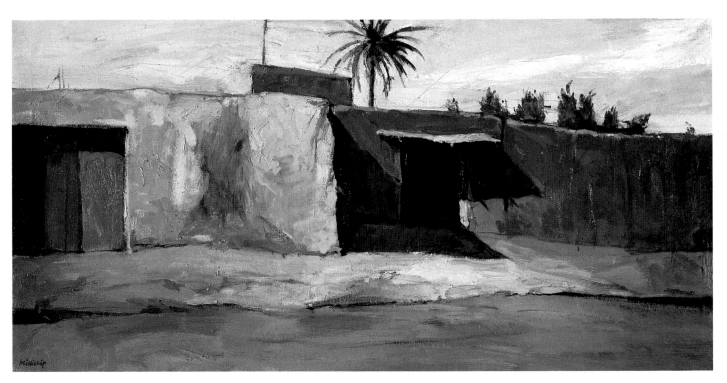

Kasbah, near Taroudant

Along the road that leads up into the High Atlas Mountains from Taroudant are several groups of pink-washed buildings housing a number of families. The cubic, almost abstract appearance of these buildings is accentuated in the late afternoon when shadows are cast obliquely across the façades. I used impasto with brush and painting knife to suggest the rough texture of pisé walls. Some Alizarin Crimson was scumbled (dragged) across the deep-violet cast shadows to help link them to the prevailing pink colour scheme. Oil on canvas, 61 × 122 cm. (24 × 48 in.)

(Right) *Detail*

which can be regarded with suspicion and even hostility.

The mountain bus rattles on upward, belching clouds of black exhaust smoke, stopping briefly for passenger refreshment at one or two mountain-village cafés before reaching the Tizi n'Test pass near the 4,165-metre summit of the highest mountain range in northern Africa. Then begins the descent to the Souss plain of central Morocco, where there are more visual thrills as the countryside stretches below like a great chequered map. However, there is not much chance to paint while the bus sways round hair-pin bends and less experienced passengers try to keep their minds off the precipitous drop four inches away from the wheels.

The bus travels across the plain, and the colours change again, as does the nature of the light. Careful irrigation and cultivation in the fertile Souss give the welcome, rich greens of the citrus and apple orchards and the fields of vegetables. There is more moisture in the air, which slightly softens the atmosphere and the edges of forms. Shadows under the closely leaved trees are a rich and dense violet (Alizarin Crimson and

Ultramarine). The one-storey *pisé* buildings, mostly farms and family kasbahs, are tawny in colour, and their walls of sun-dried mud bricks lend themselves to the subtle changes of light throughout the day. Dark-green date palms cast violet shadows over the occasionally whitewashed mud walls, some of which are decorated with roughly drawn palm trees. A solitary *ksar* (fort)

rises majestic in the plain, looking as if it grew from the rock upon which it stands. In the emerald vegetable fields and orchards the workers in their brightly coloured costumes are clearly visible, the women in white, brilliant pink or violet robes, the dark-haired men in saffron-yellow turbans.

The bus carries on across the plain to Taroudant, the elegant walled city of the Souss. Here are lively and gaily costumed crowds, tall palm trees, and walls which the sunlight of central Morocco can transform from mere straw and mud into glowing gold. Above all, there are the souks or markets, where a painter can revel in the sight and scent of brilliant spices piled high, and in fruit and vegetables of almost incandescent colour, set alongside local pottery, carpets, leather and basketry, and displayed under the stripes of light and shade cast by bamboo awnings, a revelation for any painter. Paul Klee wrote after his first North African visit in 1914: 'Colour had taken hold of me, colour and I are one – I am a painter.'

From Taroudant a straight road leads west through immense orange groves to the busy seaside resort of Agadir, where the sunlight has the quality characteristic of seaside places but is reflected from rows of concrete blocks, an anti-climax for painters after the mud buildings of the plain, whose organic nature takes the sunlight so fascinatingly. Bustling Agadir lies below a spur of the Atlas Mountains, and a favourite road of mine leads out of town through villages and banana groves and up into those mountains. This beautiful route is overhung with huge trees, including wildly angled palms, and crosses river valleys with dappled sunlight falling softly on blue stones and on red and ochre rocks, and glittering on the water.

As one climbs higher the view becomes ever more dramatic and the light clearer and more intense. The village of Immouzer des Ida Outannane makes a

Immouzer March '90

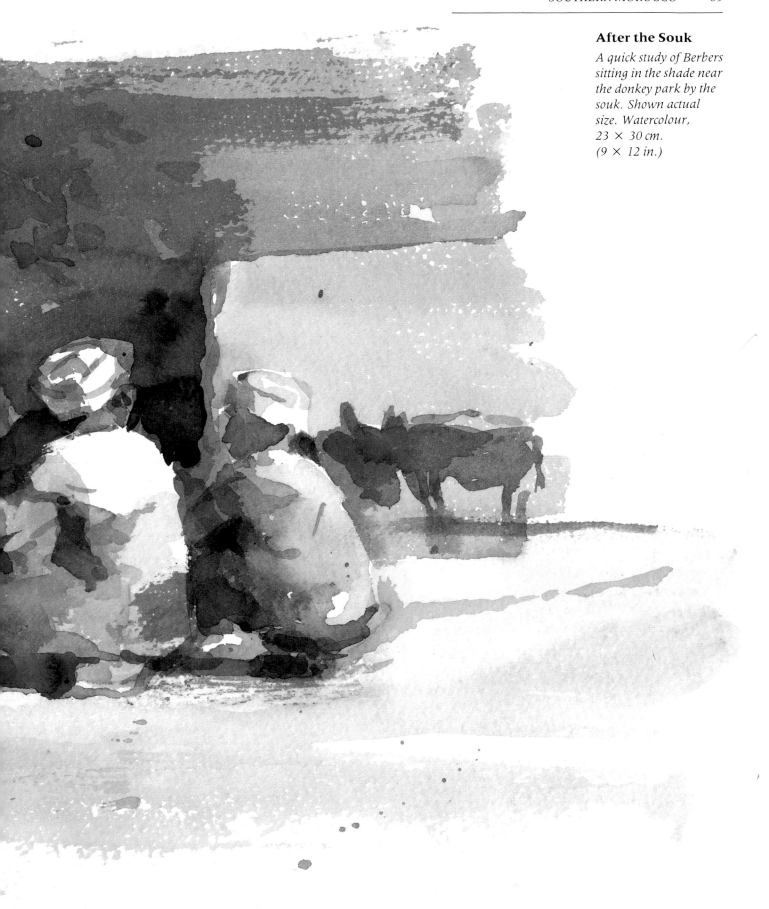

After the Souk
A quick study of Berbers sitting in the shade near the donkey park by the souk. Shown actual size. Watercolour, 23 × 30 cm. (9 × 12 in.)

convenient destination, its weekly market held in brilliant sunshine with transparent shadow, in contrast to the nearby paddock, where donkeys and horses stand in the dense shade. Immouzer can offer the painter dramatic views seawards to blue distances, waterfalls and formations of pink rock, all in that clear mountain light.

To return to Agadir and take the road south along the coastal plain is to enter a harsher environment of sandy-red soil and scrub, with occasional donkey or camel tracks leading towards distant wells or olive groves. Something about this region makes it seem a foretaste of the great Sahara Desert further south. An hour or two along this road is the bustling market town of Tiznit, with its geometrical pink-walled buildings, the French colonial influence very much in evidence. I like to pause here, sitting at a café table and ordering a drink; this gives me a chance to watch and sketch the lively town centre. The drier air of southern Morocco points up the sunlight as it strikes the purposeful robed and hooded figures, the donkeys bearing fresh green mint, and the lorries laden with fruit and vegetables.

From Tiznit, the journey south to Goulimine takes about an hour by road through ever-flatter and sandier countryside. Here on the edge of the Sahara Desert, I look out for blue-robed nomads bringing in their camels for a large weekly market. I notice how the warm dusty air tends to flatten the effect of bleached light on forms, generally

Thursday Souk

I made many drawings in this busy Berber souk in the High Atlas Mountains and later organised my studies into this painting, aiming to capture the clear, sharp nature of the light. A tonal underpainting in blue was warmed with further washes of ochre, Cadmium Red and thinned Alizarin, with some crayon work added for emphasis. Watercolour and crayon, 51 × 76 cm. (20 × 30 in.)

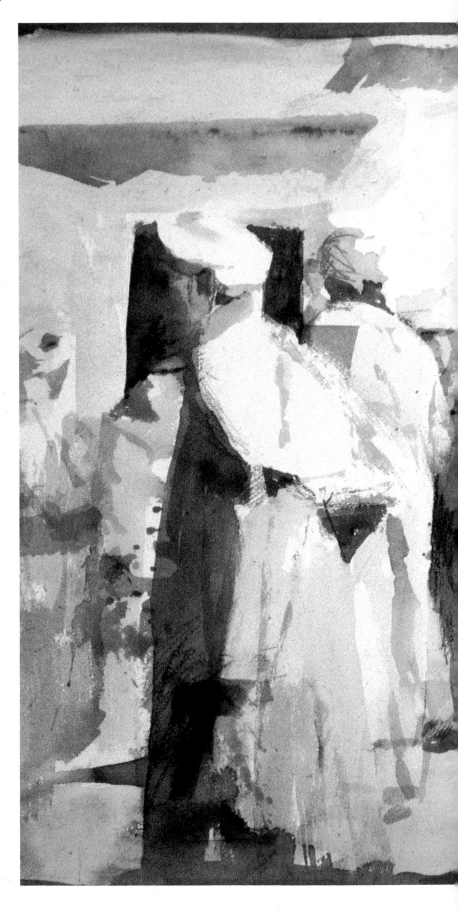

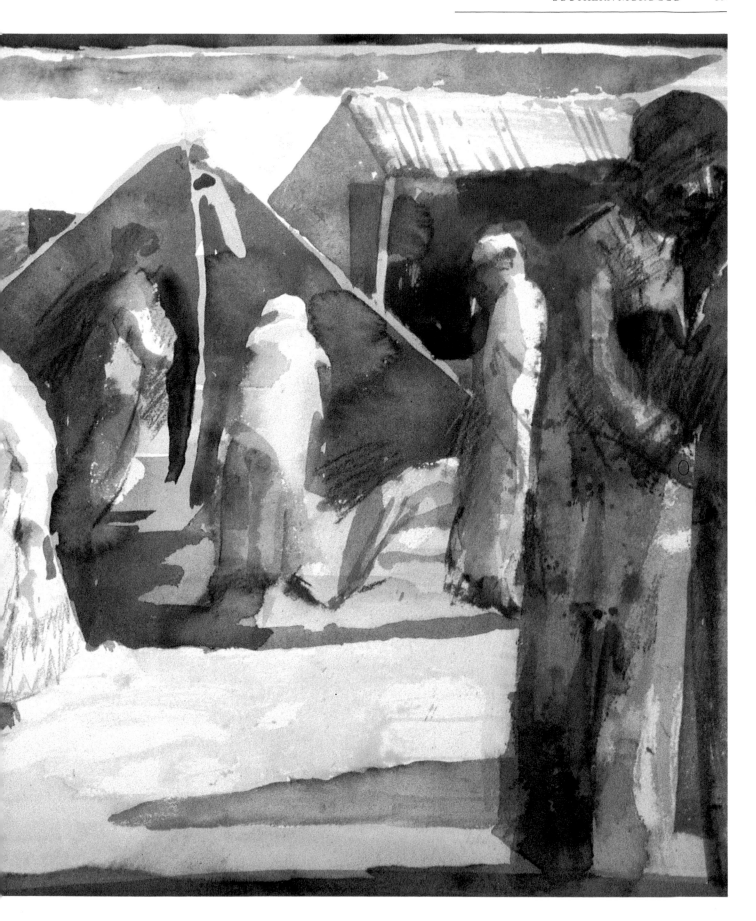

reducing strong contrasts. Any attempt to capture the southern-frontier atmosphere of this area will require careful observation by a painter. On one occasion as I sat and drew some of the locals, I was shouted at by a tribesman, who told me I must ask his permission if I wished to draw, another salutary reminder of the general dislike of image-making by Muslims.

I found that Goulimine was a good centre for painting expeditions to the oases of the Sahara. Dry sand blew across the road and desert rats scurried away as we drove to some small grouping of white-blocked buildings set amongst prickly pear and palm trees. The desert scene was especially evocative in the late-afternoon light, which caught the sides of buildings seen against vast undulating expanses of sand. These sandy wastes have a diversity and a spatial order of their own, a quality enhanced for us as we watched the huge disc of the blood-red sun slipping down behind the edge of the desert, with even small objects casting immense shadows across the sand.

Retracing the route northwards and branching off via Tiznit, an exciting road leads up into the Anti Atlas Mountains, that dramatic range lying between the Souss plain and the desert. No straight road this! Instead we follow as many twists as the tail of a rock snake, climbing amongst terraced mountainsides with dizzying views of crop-patterned valleys. The mountain air lends the light a clarity that reveals settlements of high-piled houses almost merging with the rock. Morocco's stormy history of tribal warfare has led to the construction of immense fortifications against attack – high-walled kasbahs often crown huge outcrops of local rock, with the land below these miniature mountains divided into brilliant green vegetable patches, providing more riches for the painter.

The peoples of this region complement their surroundings superbly. The women are invariably robed in deep blue with

Sketch-book study of desert oasis, shown actual size

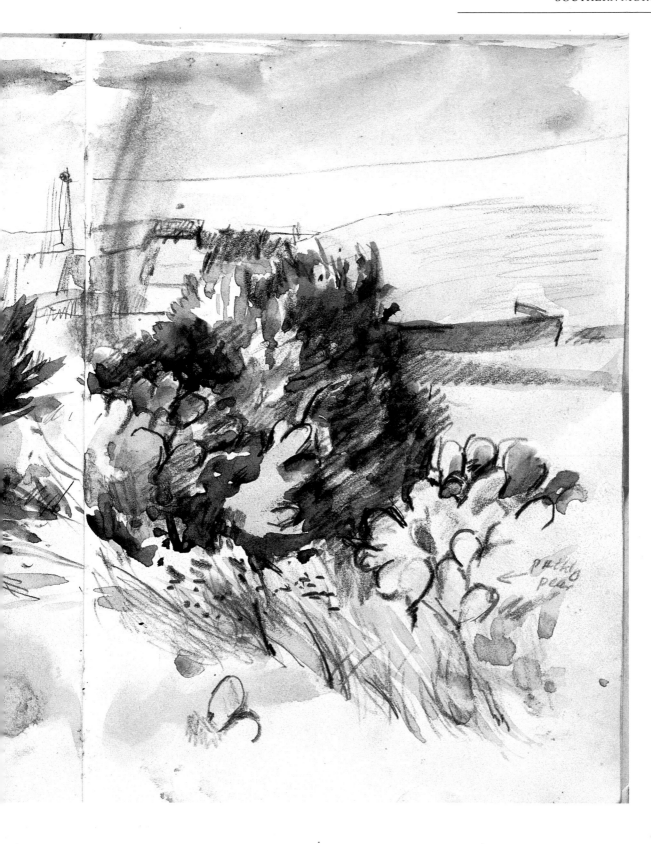

prickly
pear

Anti Atlas Village

The dramatic mountain light cast on the stone and mud walls of this village points up the contrast with the fresh greens of the cultivated fields below. A mixture of Yellow Ochre, French Ultramarine and Alizarin Crimson gave richness to the walls and rocks, with extra Alizarin dropped into the wet wash to add intensity to the darks. The green of the fields was made with Winsor Yellow and a small touch of Winsor Blue. The doorways and rock structure were added last. I kept even small areas as wet and transparent as possible so that they integrated with the painting as a whole. I never use black or dark-brown paint, which can cause the dark parts of a painting, whether in oils or watercolour, to lose their vibrancy.
Watercolour,
56 × 76 cm.
(22 × 30 in.)

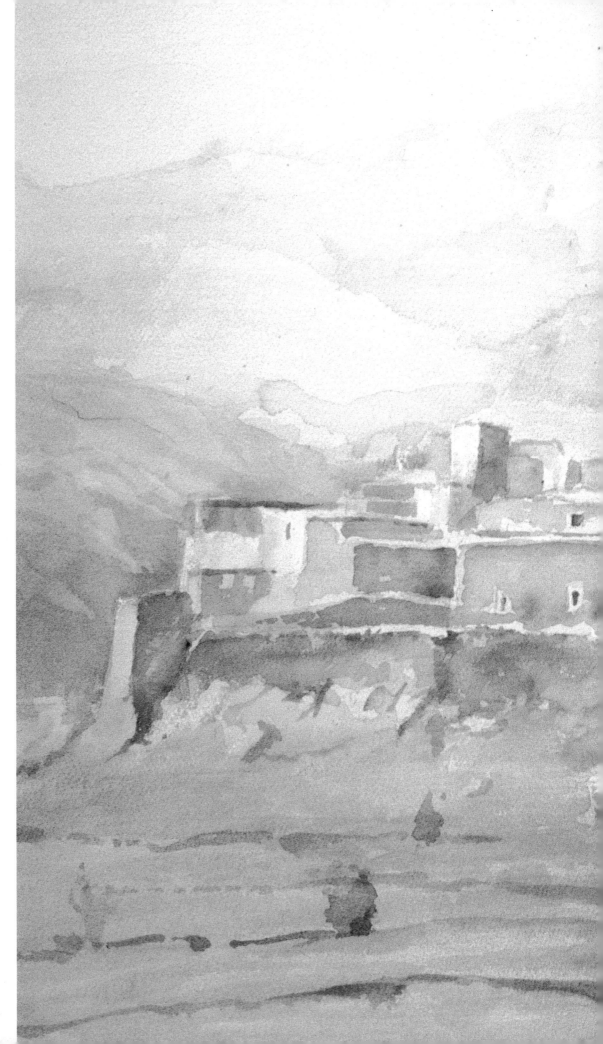

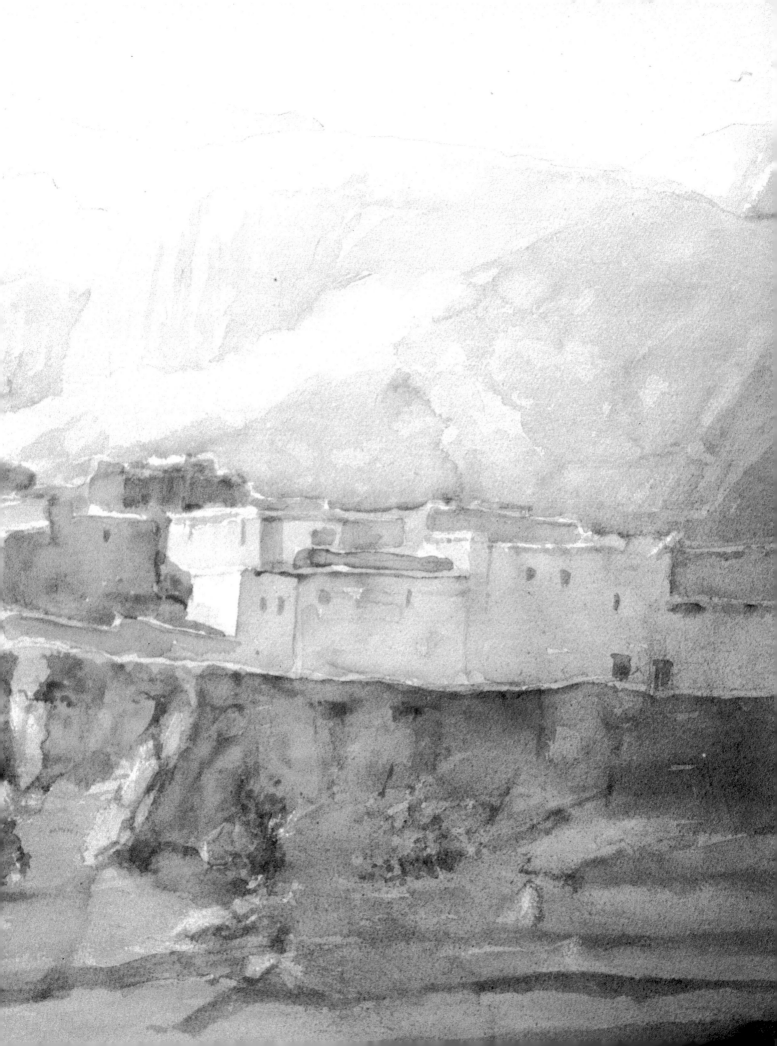

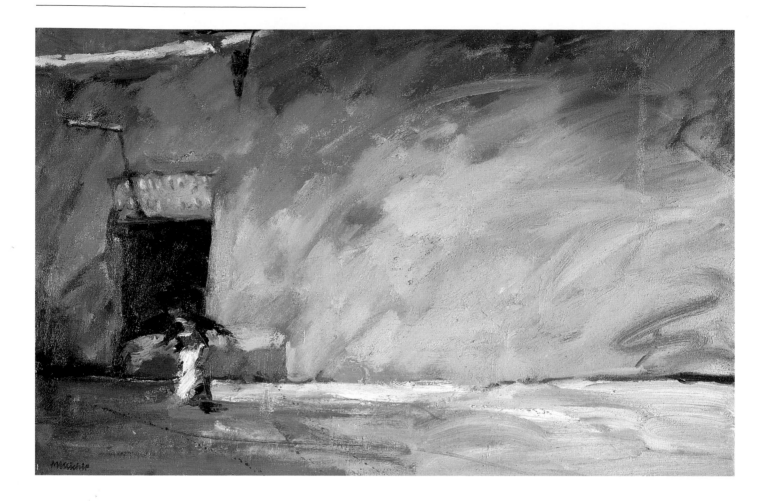

Fête du Throne

The morning sun was reflected off the surface of a high kasbah wall. The entrance made a sharp punctuation, and the running figure gave movement to the composition, while the celebratory flag was a note of bright colour against the sky. I used a fairly heavy impasto of Yellow Ochre and Alizarin for the wall area, grading this to a lighter colour near the bottom to suggest ground-reflected light. A little sand mixed with the paint helped to imply the texture of the wall. Oil on canvas, 61 × 92 cm. (24 × 36 in.)

twinkling decorations; they sit statuesquely on their donkeys surrounded by bales of mint or fodder, drawing their veils modestly across their faces as we pass, a gesture that enhances large eyes gazing with wonder and curiosity. Every turn in the road brings another dramatic view, another visual thrill, but now the route winds down from the heights to the Ameln Valley, narrowing towards palm groves set about a stream and surrounded by oddly shaped rocks, stacked or tumbled like huge sculpted building bricks.

At the centre of this strange area is the small market town of Tafraoute, a cluster of rose-coloured buildings with a special character and light of its own. The well-watered valley offers a contrast between the softer light and colour of its barley fields and palms, and the harsher pinks and ochres of the enclosing mountains, shadowed with blues and purples as the

sun goes down. The pink walls of the village change tone through the day with the movement of the light, and there are further changes as splashes from the traffic dissolve away the pink wash, revealing ochrish-browns. Blue-black sooty walls surround the wood-fired stove which heats water for the *hammam* or public bath, attended by an equally blue-black sooty bath-keeper! Rich darks are the keynote when a metal craftsman is glimpsed in his tiny workshop in the artisans' quarter, hammering away to shape a rounded copper water-jar. A woman robed in dark blue balances just such a pot on her head as she makes her way in stately fashion back from the wells through fields of bright-green young barley.

Half an hour's walk along a dusty track is the valley-side village of Tasga, barely visible from afar with its mud-brick buildings tucked amongst the huge

Sketch-book drawing of Tasga, shown actual size

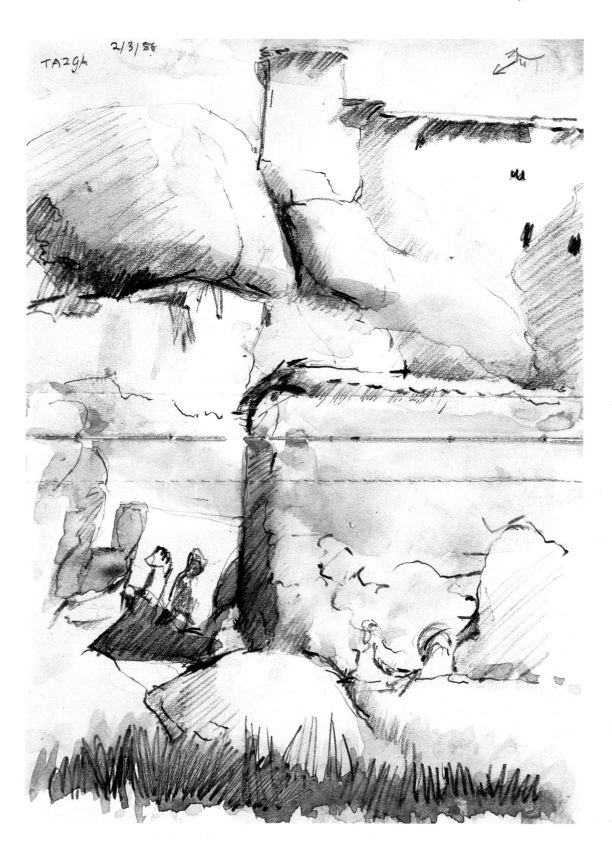

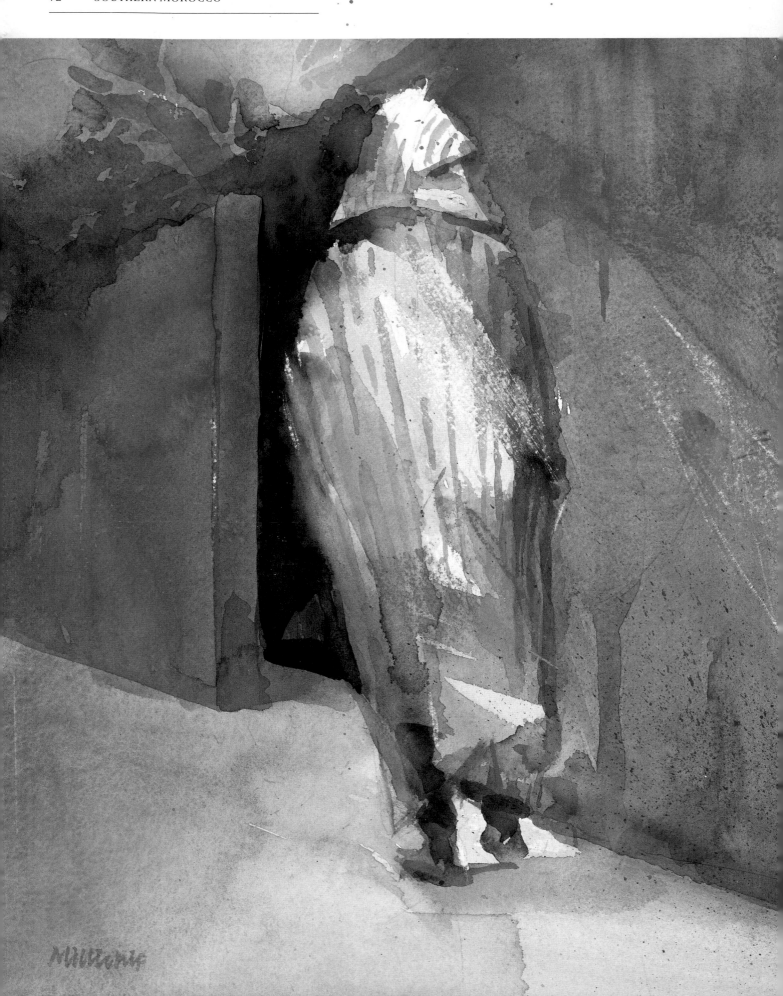

Tafraoute Street

The warm, dry North African climate, allied with the natural pinks and ochres of the rocks and soil, creates an overall light which is brilliant but partially obscured. People and buildings seem to shift and are often soft-edged in the dusty light. The strong contrasts lend a sense of drama to everyday life and even the progress of a figure can seem fraught with expectation. I made notes for this painting on an intermittently stormy day in an Anti Atlas mountain village. Later I worked using a wash of Alizarin Crimson, intensifying this to the left to suggest the mystery of the distance. Winsor Blue was used for the tree above the wall and a rich Alizarin and blue wash created the doorway. I continually dropped brushfulls of paint into this area while it was wet to create a dark colour rather than a neutral passage. Yellow Ochre was useful for the ground and, finally, a little sponging and scraping reinforced the dynamic of the figure moving against the pink wall. Watercolour, 38 × 56 cm. (15 × 22 in.)

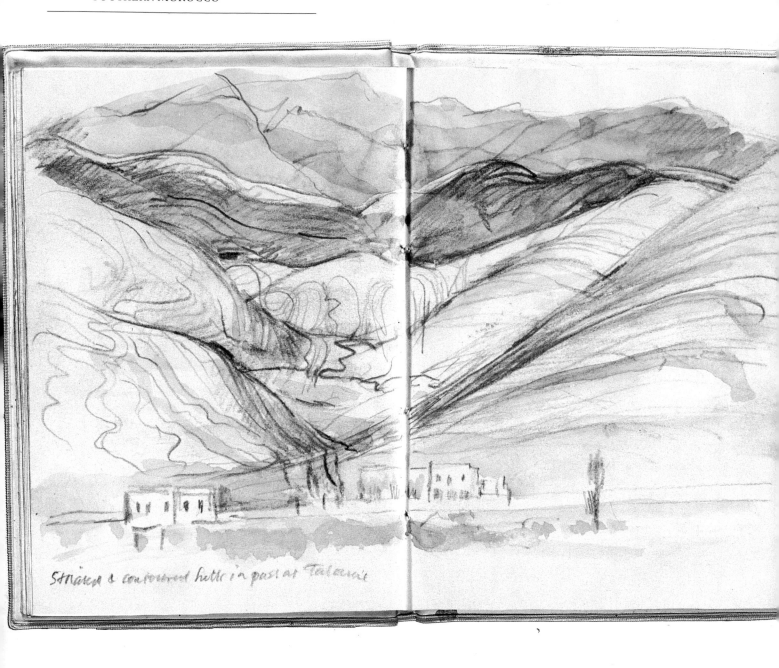

Striated & contoured hills in pass at Talaouie

Sketch-book drawing of the Taliouine Mountains, shown actual size

tumbled rocks. In spring, almond orchards sparkle with white blossom by the track up into this village, which has a medieval character far removed from more sophisticated places further north. Pale ochres and pinks predominate again as the dusty sunlight strikes the curved walls. Furtive children in bright clothes peep from between the buildings; there are no adults in sight. A few chickens root in primitive yards, while some palm trees and groups of prickly pears provide the only greenery. Occasional sounds – dogs, donkeys, roosters – break the rural silence of a place where time seems to have stopped.

Back in the centre of Tafraoute a group of Berber dancers, four distinctly stout ladies, gyrate and sing, gold teeth flashing, to the rhythmic sound of a group playing tambours and *rebabes* (a sort of lute). A drummer skilfully beats time on a lorry hub-cap. The *rebabe* player, with the characteristic Moroccan love of colour, has painted the large wooden tuning pegs on his instrument bright blue; he wears a blue hat and his protruding front teeth are blue to match!

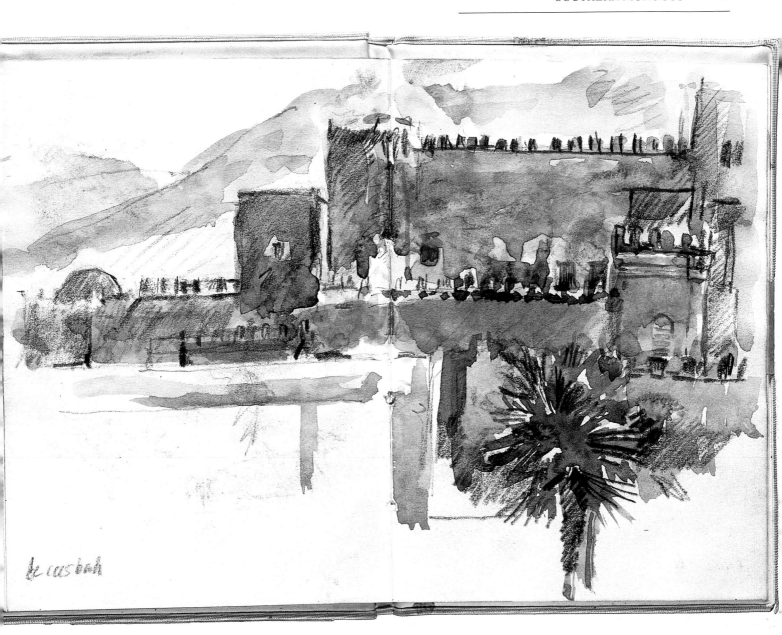

le casbah

Across the mountains, heading towards Ouarzazate, I stop to draw in the hills around Taliouine, their curves sinuously contoured by rock striations. I make a study of a pink-ochre mud kasbah as it steadily reddens in the morning sun and record its crumbling towers, which seem gradually to be reverting to the mud and straw from which they came. Like other southern kasbahs, this huge building, built and occupied by the great Glaoui tribe, has trees and flowers modelled on its façade, adornments which stand out sharply in the clear mountain light.

Travelling further south still, I come to Ouarzazate, a busy town that makes a good base for painting expeditions down both of the river valleys, those of the Draa and the Dades, which reach south-east into the desert. In these valleys the light is different again. The stony *hammada* or semi-desert has a bleak attraction of its own; grey and purple pebbles are scattered over terracotta sand interspersed with pinkish rocks and bluish barbed-wire plants. Mountains rise blue-violet and hazy in the distance; villages and kasbahs appear to float on a strip of mist. A pass

Sketch-book drawing of a kasbah, shown actual size

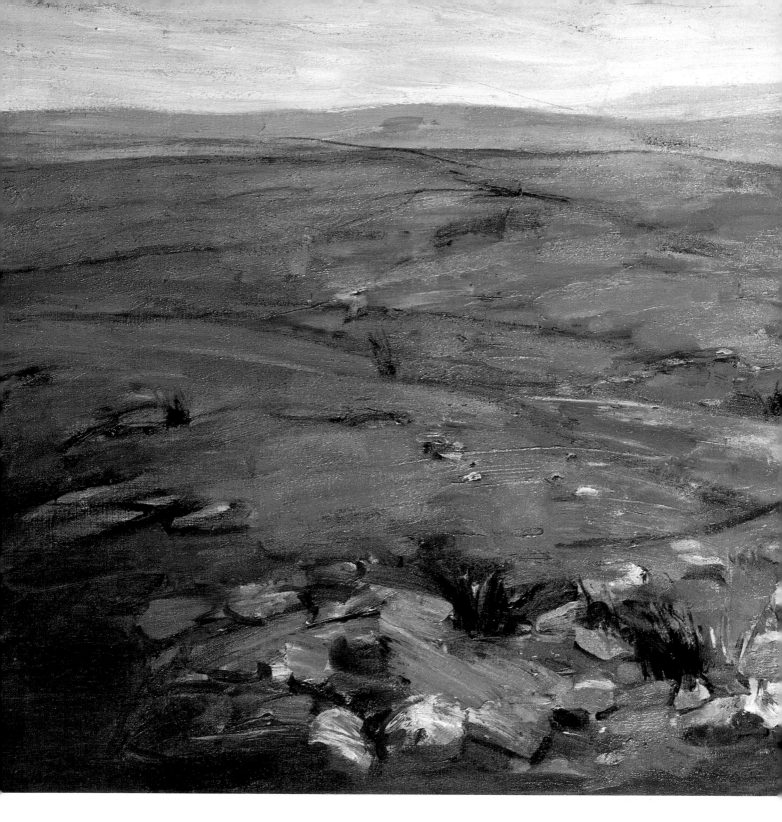

Hammada

I worked in my studio on this large oil painting to attempt to portray the nature of a particular kind of harsh and open space in the pre-Sahara region of southern Morocco. The first drawing was placed in French Ultramarine. I used a brush and palette knife, and mixtures of Yellow Ochre and Cadmium Red, sometimes with a little sand added to convey solidity and texture. Each touch of colour was intended to contribute to the spatial representation of a limitless plain under a hot sky. Winsor Yellow and Flake White were used for the sky, with a heavy impasto of crimson in the foreground colour passages. Winsor Blue cloud shadows reinforced the idea of rolling contours. Oil on canvas, 86 × 145 cm. (34 × 67 in.)

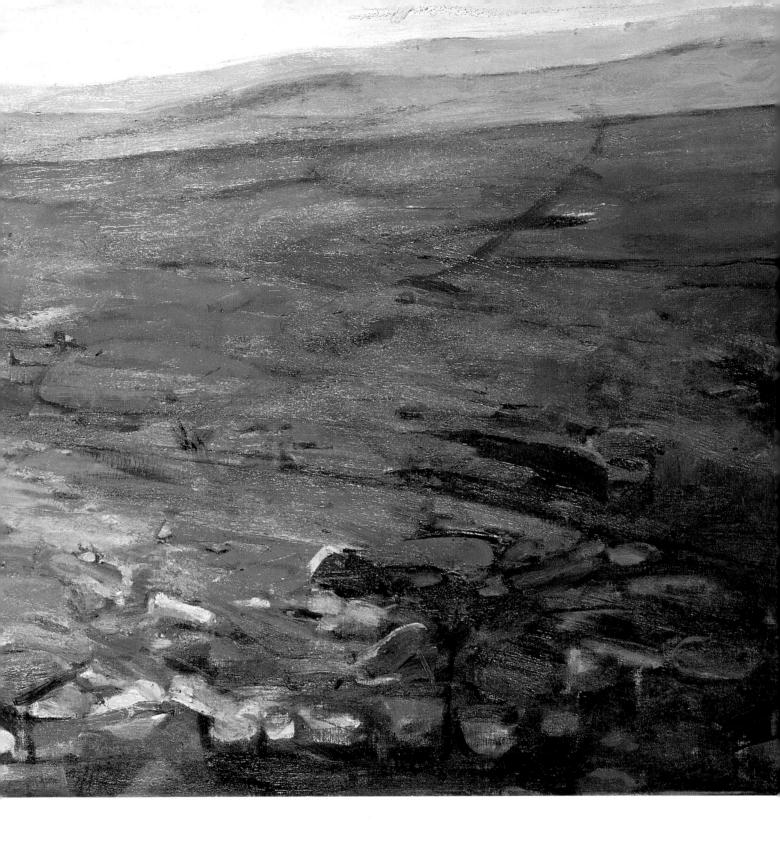

with dramatic views leads towards the Draa river, near which are large palmeries and bright-green wheat fields, with distant *ksai* topping any slightly raised land. To attempt to convey the space and atmosphere of this region will probably require a strong ochre-reddish foreground and a hazy-blue to blue-violet distance. Roadside villages further down the Draa are cubic *pisé* structures, which relate beautifully to the strong crimson-pink of the soil and sand, while the sunlight filtered through dust makes for violet shadows. This is a harsh, dry landscape, barely softened by sporadic growths of yellow and mauve flowers.

Sometimes the villagers decorate the forbidding outside walls of their kasbahs with relief patterns, and outline doors and windows with lime wash. Seen in the shimmer of the midday heat, these wind-battered buildings are like geometric outcrops of rock, and the organic nature of the building material causes their surfaces to change constantly with the light. Sunlight is reflected from the ground, and an occasional rain shower can bring out a deep crimson near the tops of walls. Ochres and crimsons will certainly be most in demand by the painter in this region.

To drive from the hot, dusty south across to the Atlantic coast of Morocco is to exchange a hazy and partly obscured painting light for one that is sharper, clearer and more defining. At the same time the ochres, violets and crimsons of the *hammada* give way to the

Draa Valley Village

Cubic pisé *buildings, silhouetted by the morning sun, rise up behind the hazy mid-distance of palms and barley fields. The glare of sun against dust and mist made distances deceptive. Well-diluted crimsons and ochres helped to create the atmospheric quality I sought in this study. Watercolour, 36 × 53 cm. (14 × 21 in.)*

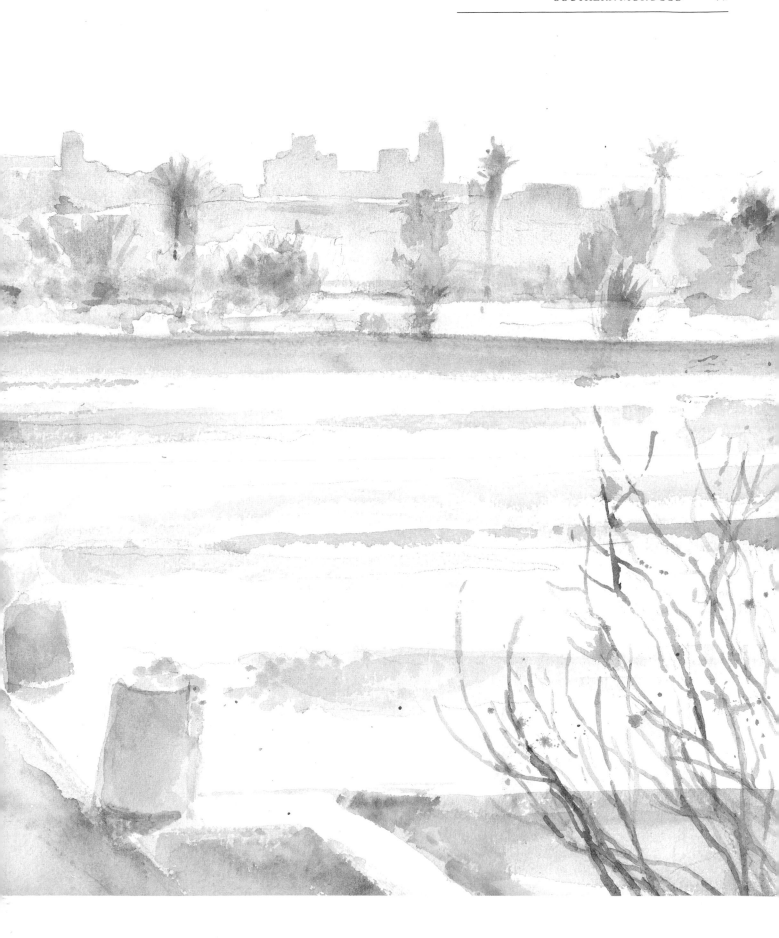

Essaouira Street

An ochrish yellow and a bright blue predominate in this Atlantic-coast town. Layers of crayon went to build the shadows. Crayon, 35 × 23 cm. (14 × 9 in.)

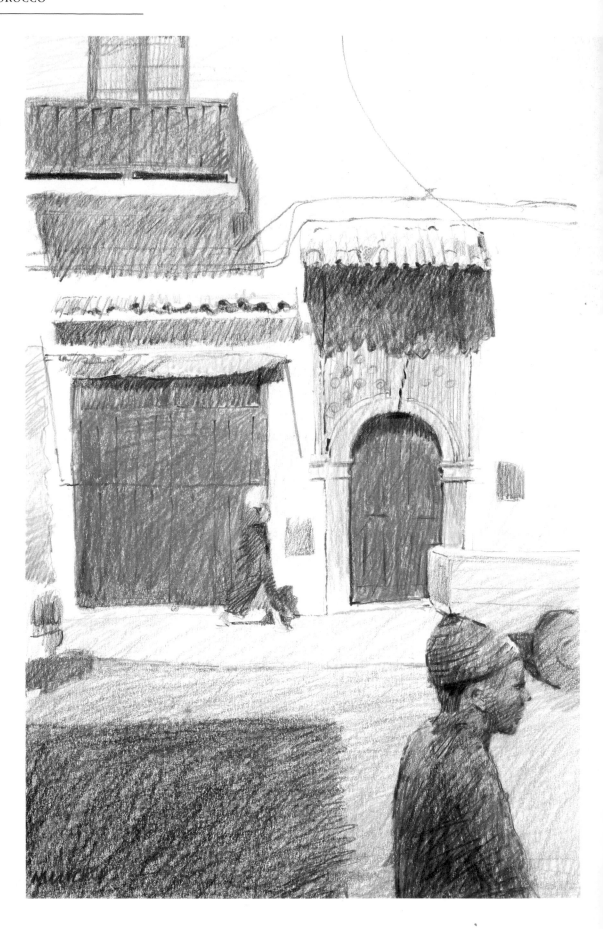

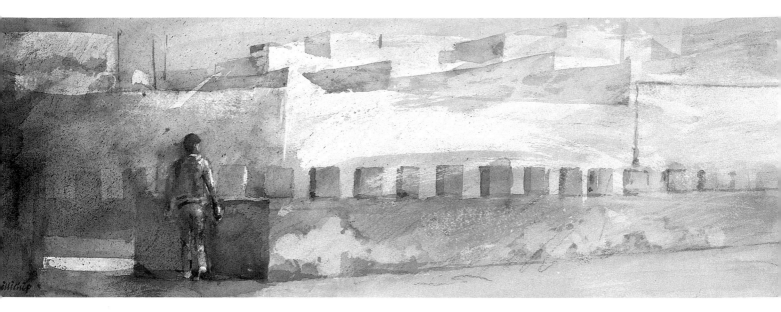

whitewashed and pink-washed stone of the coastal towns. Of these, El Jadida and Azzemour are outstandingly handsome, but my favourite as a painter is well south of these: Essaouira. This is a town with an immediate colour appeal, its white houses and mosques rising from behind pink, eighteenth-century walls with decorated gateways, and its busy sardine-fishing harbour and massive Portuguese stone ramparts confronting the thunderous sea. Doors and window frames are painted a universal Ultramarine. (In February I noted a hardware store well stocked with cans of blue paint ready for use in the spring.) Ochre bands are painted round the bases of buildings and archways and all this colour is echoed on the wide, flat beach, where blue sky is reflected in the shallows as they lap against the sand. Heavy white material is widely used for robes and djellabas and, together with the blues, pinks and oranges beloved of Berber and Arab, this makes a kaleidoscope of every street. Blue appears again on the prows of local fishing boats, in the nets themselves and on the woollen hats of the fishermen – plenty for me to record when, sketch book in hand, I tour the harbour to look for the essence of the place.

On this Atlantic coast the atmosphere and the light can change rapidly. When the prevailing on-shore breeze drops, the sea mist can envelop the town, obscuring colour and reducing tonal contrast. A brightly coloured view becomes a monochrome mezzotint. As a painter I can either wait for this mist to clear or make the most of the dramatic change of mood offered by the altered light. In Essaouira the great grey-stone ramparts look particularly impressive when the mist hangs over them, partially obscuring the town behind and presenting an opportunity for painting that I have used several times. I remember a band of travelling musicians walking the street below the ramparts on such a day, the melancholy sound of pipe and drum combining perfectly with the mist-wreathed battlements.

Morocco is a large and varied kingdom in which the prevailing light seems to me to be inextricably linked to the visual images presented. I have drawn and painted here in many kinds of weather, but the local light always prevails, lending special character to the scene. All the different aspects of Morocco, from the mud architecture seen in huge kasbah walls, farm compounds and small dwellings, to the brilliant costumes, the countryside and the wild, exotic music, combine to make a powerful and lasting impression on any visitor.

The Ramparts

Sea-spume and mist add to the atmosphere of these great Portuguese-built stone ramparts. Masking fluid, applied with a hog-hair brush in sweeping strokes, was used to suggest the swirling mist. An initial wash was graded from pale Cadmium Red and Yellow Ochre on the right to Ultramarine on the left. After removing the masking fluid I reinforced the drawing with fluid touches of ochre and blue, and sponged the area on the right to increase the light-to-dark interval. A little toothbrush splatter-work in blue in the left-hand area strengthened the contrasts further. Watercolour, 27 × 74 cm. (10½ × 29 in.)

As Delacroix says in his journal, 'They [the Moroccans] are closer to nature in a thousand ways, their dress, the form of their shoes, and so beauty has a share in everything they make.' Although Morocco, especially in the north, shows ever-stronger Western influence, there still prevails a firm underlying tradition that makes me feel sure that Delacroix, if he returned today, would have little difficulty in recognising the country he visited in 1832. Truly, Morocco may be said to be a painters' country.

Essaouira, the Port from the Beach

Heavy seas and Atlantic rollers break on this beach, and the distant harbour buildings, as reflected in the shallows, repeated the colour theme of blue and ochre which pervades the town. By lightly sponging my washes and using a little crayon over them, I was able to produce the effect of light reflected off the sheet of water that covered the sand. Watercolour, 51 × 71 cm. (20 × 28 in.)

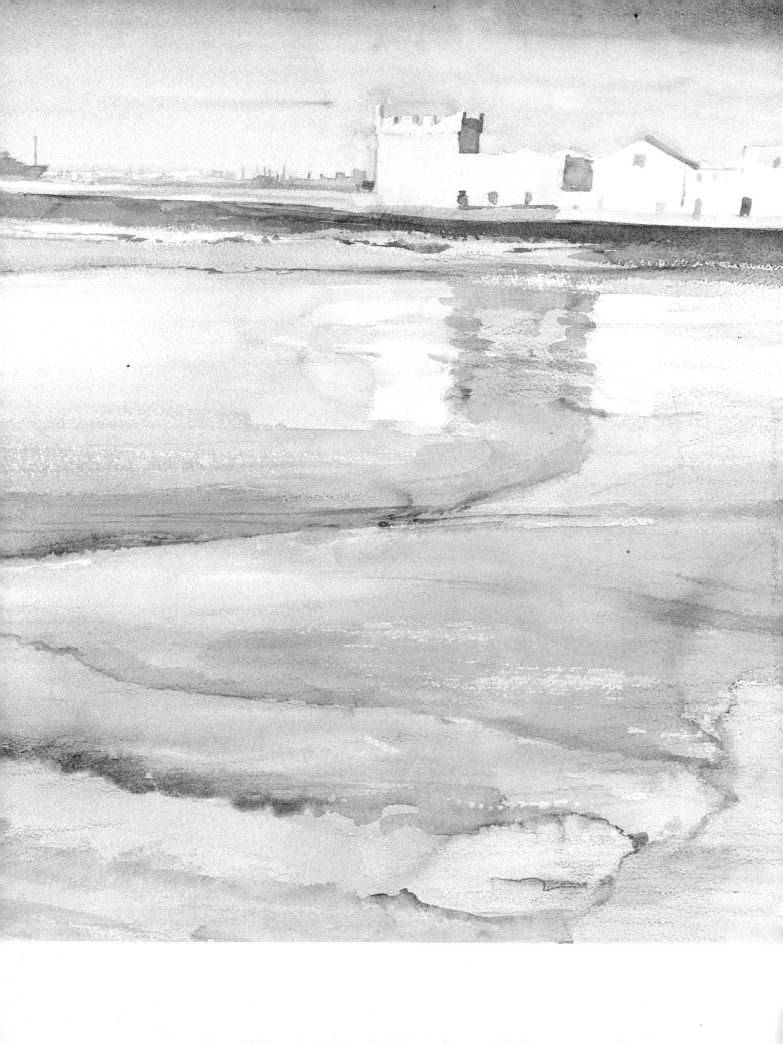

(This page) Late Afternoon, Manhattan Reflections

Daylight in the concrete and glass chasms of Manhattan is inevitably affected by the city's position as an island, and reflective glass façades can take on some of the nature of the water which is never very far distant. I was attracted by the visual counterpoint of lights behind the glass, and buildings reflected in it. Masking fluid placed the lights in the glass, and I indicated the glazing lines with a fine brush – holding my breath! Watercolour, 46 × 28 cm. (18 × 11 in.)

(Facing page) North Carolina Porch, Morning

The angled bluish shadows in this painting were mixed with green, filtering through from the trees outside. Broad washes of French Ultramarine went on first to establish the mood, and Winsor Yellow and Yellow Ochre were flooded over to warm the blues in places. Alizarin Crimson helped to create strong darks. Touches of ochre pastel were added later, while a little white gouache conveyed the precise edges of light on the screen frames. Watercolour and pastel, 36 × 53 cm. (14 × 21 in.)

AMERICA – THE EASTERN COAST

Our hostess is describing the crested woodpeckers found in this area: '. . . huge great things, with beaks the size of a pickaxe.' A pickaxe? Of course, we are in America, the southern states of America at that, where everything tends to be well above European size – roads, motor cars, houses, boats, people, even birds. I am sitting on a porch (in Britain we might call it a veranda), a rear extension to a timber-built house in North Carolina. This indoors–outdoors room, with its mosquito screens and trellis instead of glass, its white painted walls and wicker furniture, is constantly subject to weather and the changing light of day. At the end of the garden the sea is glimpsed through the oak trees. The whole setting is worn, weather-beaten and beautiful.

As we eat breakfast, the cool light of a late-autumn morning, combined with blue reflected off the sea, filters through the screens, washing over the table and the people seated there. My first attempt to render this in watercolour involves deep excavations into the blues on my palette; in fact I start with washes of Ultramarine to achieve that 'autumn morning by the sea' mood, adding further colours once this is established. An hour or two later a sudden storm agitates the trees and the water outside, so that the porch space becomes a dark silhouette against the sky. The weather clears again by lunchtime, and in the afternoon a little gold is introduced into the blues and greys of the interior. I notice the way the sunlight strikes the arm of a cane rocking

Pencil study of an approaching storm. The silhouetted live oaks in this drawing contrast well with the angles of the porch structure.

The Porch, Late Afternoon

Masking fluid was used to create the spaces between tree branches and screen-door verticals. Washes of blue-grey (made up of French Ultramarine, Cadmium Red and Winsor Yellow) were combined with Alizarin Crimson, French Ultramarine and Winsor Blue for the right-hand foreground. After the masking had been removed the left-hand washes were scrubbed down under the tap to achieve the effect of light through gauze screens, with a little sandpaper and knife work to bring out the lights. Watercolour and pastel, 36 × 53 cm. (14 × 21 in.)

chair and a garden sieve hanging on the wall, and I try to capture in paint the special atmosphere created by the afternoon light. In early evening the sunlight fades and warms, reflecting pink and gold from the ocean as it seeps through into the porch, changing the atmosphere and even the apparent dimensions of the space. Corners are thrown into deep shadow and patterned rectangles of brilliant colour are projected through trelliswork onto the mosquito screens. The evening light transforms the scene yet again, and this becomes the impetus for another painting.

These experiences of light in North

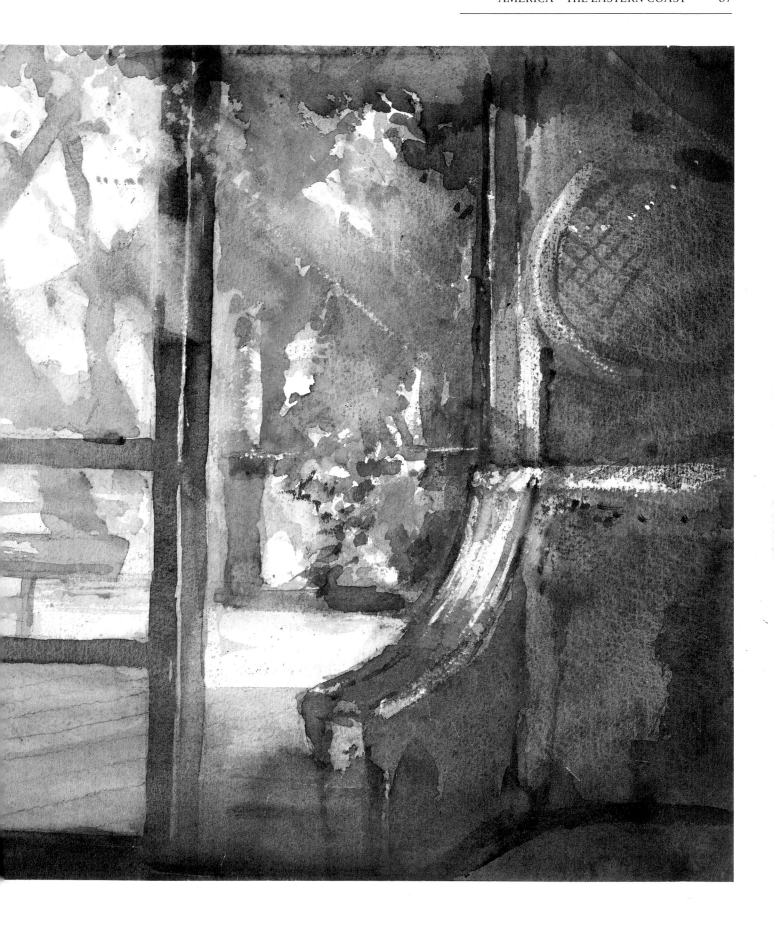

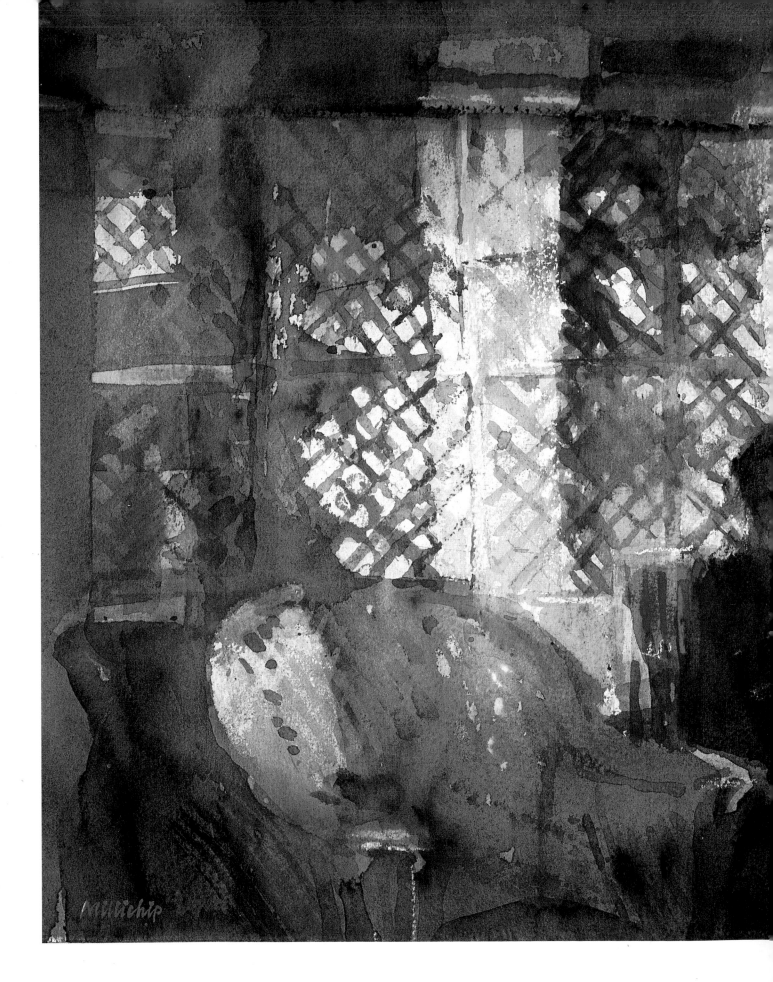

The Porch, Early Evening

A pink wash (Alizarin Crimson and Yellow Ochre) was laid on first over masked spaces. Very fluid washes, with Winsor Blue dropped in, helped to create an atmosphere of indeterminate shadow, combined with yellow, orange and red pastel. Watercolour and pastel, 36 × 53 cm. (14 × 21 in.)

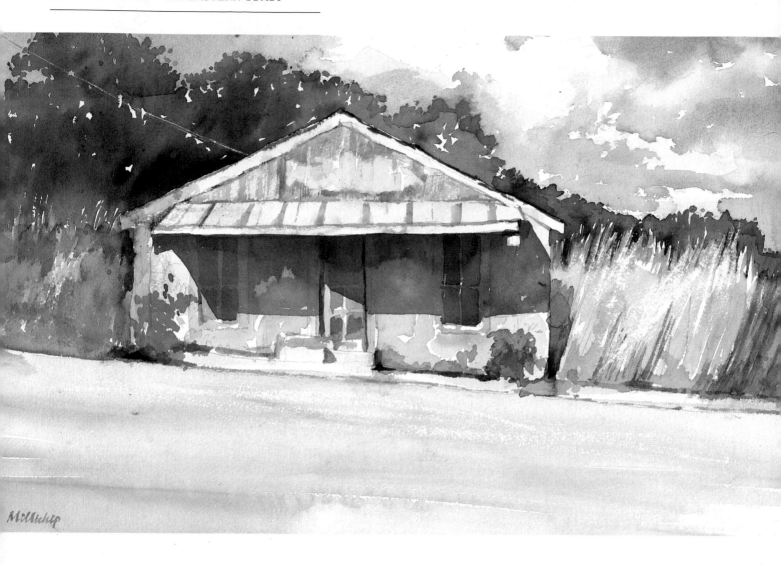

Millichip

(Above) Derelict Fisherman's Store, Orient, North Carolina

The Outer Banks of North Carolina have a particular quality of clear, soft light, with the gold of the sedge showing brilliantly against both sea and trees. Even on a slightly cloudy day there were enough flashes of bright sunlight to illuminate this modest building, its ghostly fish sign peeling beneath the gable. Watercolour, 31 × 51 cm. (12 × 20 in.)

Carolina were still in my mind as I sat and drew in the late-afternoon sun on a floating jetty in Gloucester, Massachusetts. Here, several hundred miles up the coast, a cooler, clearer light prevailed, recalling the work of those late-nineteenth-century American East Coast painters now known as the Luminists, who celebrated the quality of this light. As I drew I noticed the precise nature of the shadows. It was easy to see why Gloucester and nearby Rockport had become popular among artists, with exhibitions and galleries at every turn. The colourful buildings and the activities of the fishing fleet combine with a good, positive light, proving a magnet for painters. In the clear morning sun the white painted lighthouses along this coastline show brilliantly against the sky,

(Right) Gloucester Harbour, Massachusetts

A local mariner had placed a convenient table and bench on a floating jetty in Gloucester Harbour, and I sat here whilst making notes for this painting. Warm, late-afternoon sun and the soothing rise and fall of my vantage point helped me to concentrate on the contrast between the clarity of the shadows on the cabin annexe,

and the indistinct mystery of the worn wooden supports. Preliminary work with masking fluids was followed by washes of red, merging into violets and blues for the lower areas. Later, touches of crayon were used to add some extra definition to the supports. Watercolour and crayon, 56 × 36 cm. (22½ × 14½ in.)

Eastern Point, Cape Anne, Gloucester, Massachusetts

On a Sunday morning in late autumn I sat on a granite breakwater, the sea crashing on the stones below, whilst making studies for this painting. I looked especially for the tonal relationship between the sunlit sides of the lighthouse and the surrounding buildings, and also for the grey-blue translucent sky, which formed a backcloth to the scene. I deliberately placed the lighthouse high in my composition as the apex of a triangle, the other two points being the breakwater jetty and the headland buildings. An underpainting in French Ultramarine helped create a seaside atmosphere. As Ultramarine is less aggressive than Winsor Blue, I usually prefer to use it to build on an underpainting. Yellow Ochre established the headland and a useful warm-coloured stone in the foreground, and washes of pale Cadmium Red helped to warm other sunlit stones on the jetty. Alizarin Crimson over my blue underpainting added a positive note to strongly shadowed foreground passages. Light sandpapering helped to capture the sparkle of sun on granite. Watercolour, 38 × 55 cm. (15 × 21 in.)

Eastern Point, Gloucester Mass.

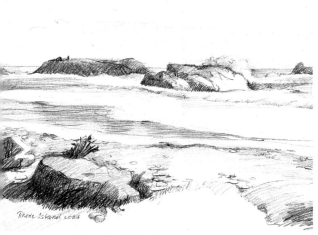

*Pencil study of Rhode
Island coastline*

bringing the work of Edward Hopper to
mind. The local colours, with their sharp
tonal range, present a vibrant contrast to
the warmer semi-tropical light in the
southern states.

An enjoyable painting stay in
Massachusetts was followed by a brief
visit to the small state of Rhode Island.
I spent enough time here to form a vivid
impression of the sparkling light which
the sea lends to this stretch of rocky
Atlantic coast, where sunlight reflects off
the spray from the long breakers. The
shingled houses and churches in this area
seem designed to show at their best in a
light which carries the sea's influence
even in inland areas.

This same light was certainly pervasive
when we visited some attractive old
towns down on Chesapeake Bay,
including Annapolis and St Michaels,
each with its complement of artists. Local

Manhattan Clouds

*The world-renowned
skyline of Manhattan,
seen from across the
Hudson river, looked
even more impressive
with clouds capping the
taller buildings. This
painting was based on a
quick pencil note. I
looked first for the
different silhouettes of
the buildings, and
placed these with a
basic wash of French
Ultramarine and
Cadmium Red, which I
also used for the clouds.
Watercolour,
26 × 36 cm.
(10 × 14 in.)*

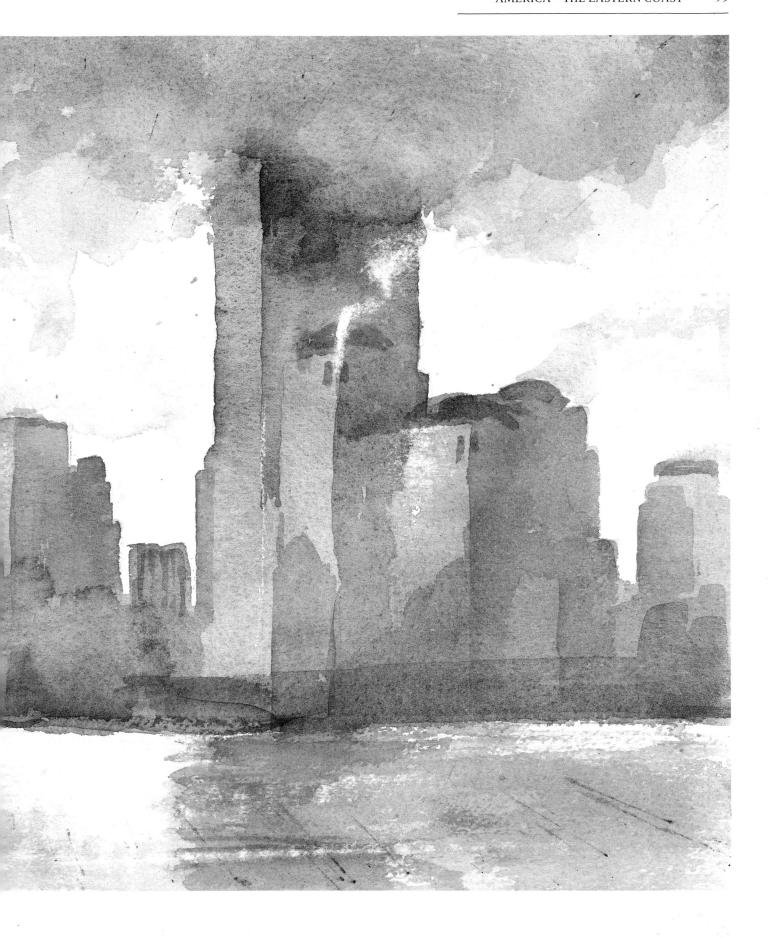

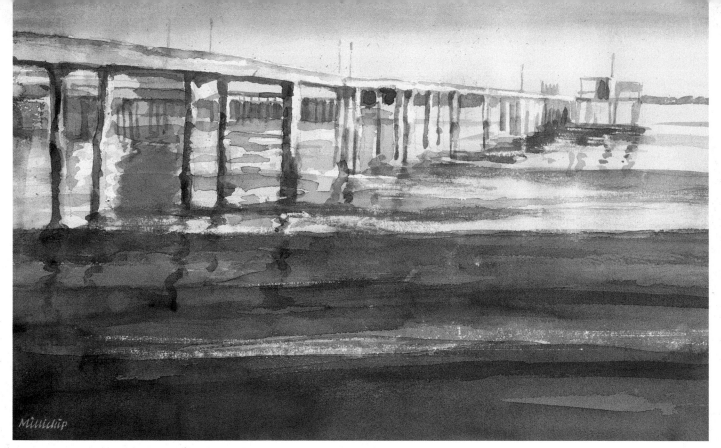

colours, such as yellow buoys or a clutch of white-hulled yachts, showed strongly when the sun was veiled, and even more so under rain. The sharp clarity of Mediterranean sunlight will not be found on this coastline, nor will the accompanying transparency and intensity of brilliant, light-related shadows. However, visitors from northern Europe will certainly feel some affinity with New England, with its delightful towns and fishing ports seen under hazy sunshine or sea mist.

A few days in New York made a fitting end to our tour of the eastern states. Like all great cities, New York has been celebrated many times in the paintings of artists who visit or live there, many of whom have shown their awareness of the particular quality of the light. In the bustle and noise of Manhattan I found it easy at first to forget that this was an island surrounded by great rivers, which add an extra dimension of reflective light to the glass-walled skyscrapers. However, I soon saw how these massive buildings can change their appearance by the minute, according to the weather. A sunlit, glazed ravine can suddenly turn

(Above) **North Carolina, Study of Jetty**

Late-afternoon light caught this long jetty and turned its sea-scrubbed timber to

threatening as a storm rolls across from the Atlantic, darkening those acres of wall in seconds. This interaction between the man-made environment and nature presents a special challenge to painters of urban landscapes, a challenge which I found daunting but exciting. My visit to New York was necessarily short but I left intending to return and record the unique quality of light to be seen on the eastern seaboard of the vast American continent.

The coast of the eastern states of America is long and varied, and a painter's experience of light here can be equally diverse, although the ocean always acts as the overriding influence on prevailing light and colour. I have mentioned a few of the painting pleasures and visual delights that I have enjoyed along these shores. You, as a travelling painter, will surely discover others.

bronze, which was richly reflected in the sea swell. Winsor Blue and French Ultra-marine predominated with notes of pure Alizarin in shadows and reflections. Watercolour, 31 × 46 cm. (12 × 18 in.)

(Right) **House in Beaufort, North Carolina**

Clear morning sunlight cast tree shadows across the elegant front of this balconied house. I used some masking fluid to achieve the crisp edges of these shadows. French Ultramarine and Alizarin Crimson in very wet washes created the deep, rich shadows I found so resonant in this subject. Watercolour, 45 × 36 cm. (17½ × 14 in.)

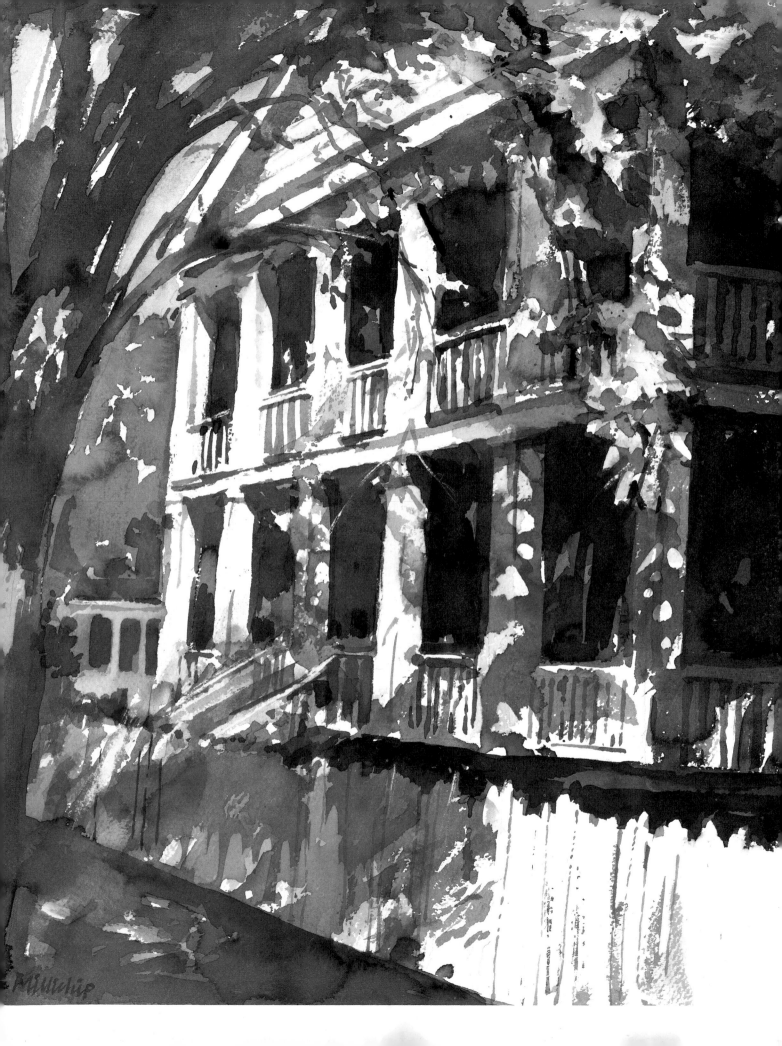

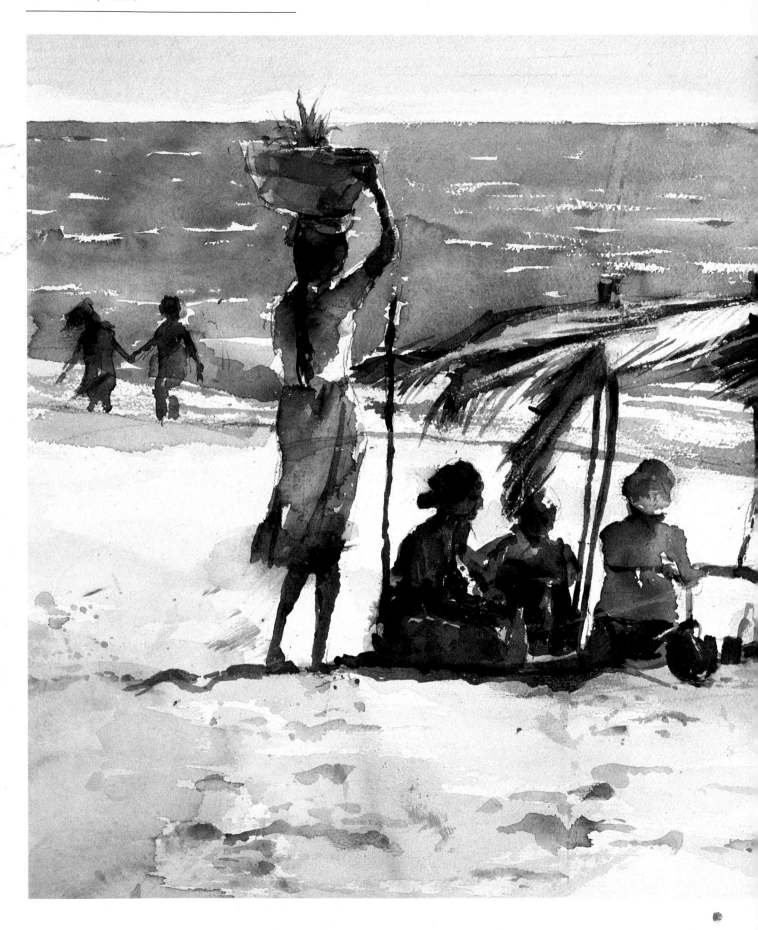

GOA, INDIA

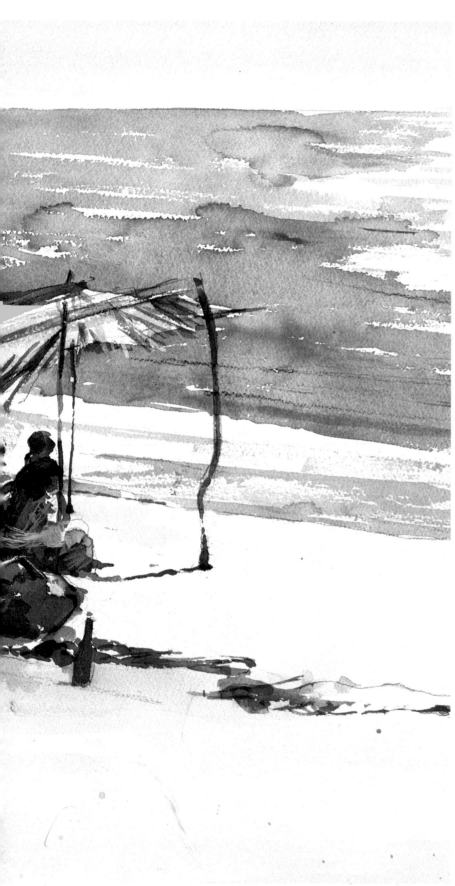

I bought myself a new pair of sandals before visiting Goa, surely a good preparation for spending time in a tropical climate. It was those very sandals that I could now feel filling with river water as I stood on the car deck of the ferry from the Goan capital Panjim, crossing the Mandovi river. After a successful day's painting expedition to the southern coastline of Goa, I had arrived at the ferry in time for Panjim's evening rush hour. Swarms of motor cycles and pedestrians rushed onto the already overloaded ferry, preventing the tail gate from being lifted properly on its chains. Crushed in the dark in the press of homeward-bound workers, I could not see my feet but I could feel the river seeping across the deck and lapping my ankles. The Mandovi is not especially wide at this point, but its currents are strong and it did not help my peace of mind to glance up at the newly built road bridge crossing the river and see that its central spans had collapsed. With the northern shore safely reached, the good-humoured Goans crowded off, chattering cheerfully. The only remaining hazard on our homeward journey was to avoid the free-ranging sacred cows which lumbered erratically across our unlit road. 'The cows are God,' said our driver as he swerved yet again.

Goa's monsoon season had finished just before our arrival, although we still had the occasional rogue shower. The brilliant

Beach Shelters, Calangute

The palm leaves and bamboo stakes of a sun shelter made for attractive shapes on the long sandy shore. The figures beneath these shelters were silhouetted by the mid-morning light, which was also reflected from the sea and sand. A bluish wash was used to underlie the grouped figures, and local colours were dropped into this wash before it dried. Touches of dark colour accents were added last.
Watercolour, 53 × 74 cm. (21 × 29 in.)

red soil was moist and the humid air combined with strong sunshine to produce a light of a kind I had not experienced anywhere else. Most days the sun shone high from a pale-blue sky, shadows were soft edged and had the density but none of the transparency of Greece. We were staying in an area with the beach and sea on one side, and thick groves of palm and banyan on the other. Inland, beyond these, were wide stretches of paddyfield. It was a gentle, idyllic landscape with wonderful opportunities for a painter, and I was enchanted.

A stroll along the broad beach, which stretched towards a palm-crowned promontory, gave me a chance to sample the seaside light of this section of Goa's coast. Sand-crabs scuttled away and disappeared down tiny holes in the beach as we walked. A slightly hazy sun made for pale shadows that were barely discernible at ground level. The strong sculptural shapes of the Goan fishing boats drawn up on the beach were flattened to dark silhouettes. The day's catch was being hauled on shore by slim, dark-bodied men, and a small crowd had gathered to watch the tumbled mass of silver fish gleaming in the morning light. Women in brilliant saris moved past, many of them fruit-sellers with immense baskets of pineapples, bananas and oranges balanced on their heads. Sun caught the curve of the breakers as the Arabian Sea pounded the shoreline. The overall sense was of space, peace and a relaxed, rhythmic way of life.

Early Evening, Calangute Beach

Low November sunlight combined with clear evening air to pick out this family group, whose brilliant reflections were seen in the shallows. Masking fluid was helpful in preserving the shapes of the figures and the sparkle of light on water. I used a broad house-painting brush dragged lightly across the paper to establish the movement of water across sand. Watercolour, 51 × 74 cm. (20 × 29 in.)

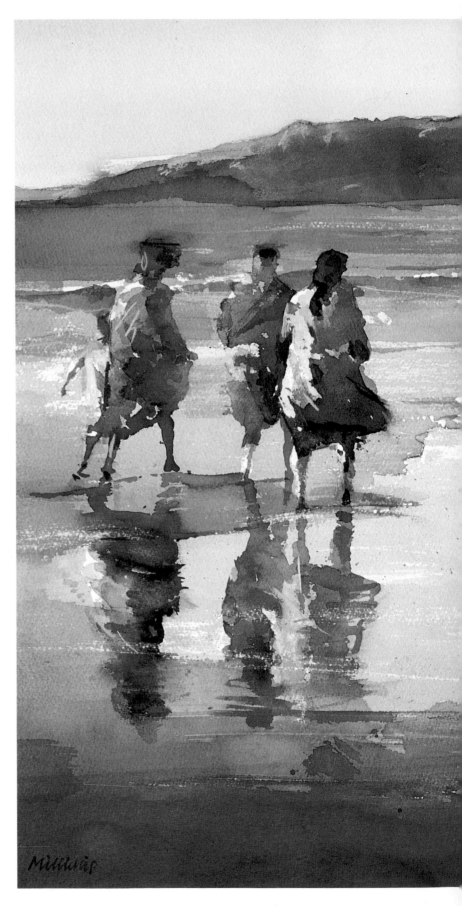

Fishing Boats, Baga Beach

On a very warm morning in early November I sat on a section of dismembered boat and drew the silhouetted shapes of two boats from the local fishing fleet, with part of an outrigger in the foreground. As I was looking into the sun, I needed to define the broad shapes strongly, yet hold them in place spatially with the positive line of the outrigger. The slightly hazy light imposed lost-and-found edges, whilst the ochres and pinks of the sandy beach reflected onto the boats and the figure.
Watercolour,
53 × 74 cm.
(21 × 29 in.)

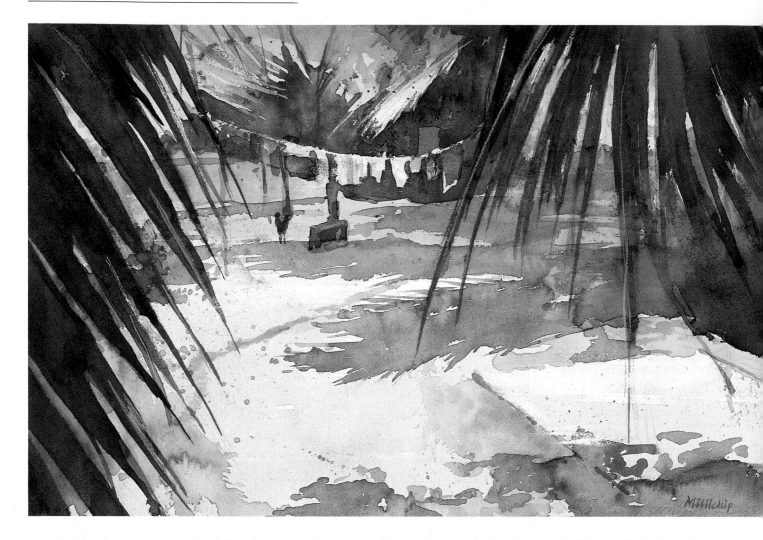

Goan Village

Dangling palm fronds provided a useful frame for this glimpse of a small Goan settlement, deserted but for a few chickens and pigs. Again, a red underpainting served to help, with strong, rich darks setting off the more distant greens. Since this subject was near the beach, the soil was sandy-ochrish, leading to a different quality of reflective light. Watercolour, 36 × 54 cm. (14 × 21 in.)

The following morning seemed a good time for the walk of a mile or two along to Baga, the adjoining village. It was hot in the tropical sun but soon the road became an inviting tunnel of greenery amongst coconut palms, banyans and other richly leaved tropical trees. My painter's eye noted the totally different nature of light here, together with the way in which this affected the sense of space. A high canopy of leaves provided dense shade, and the occasional breaks in this canopy made structures such as a painted household shrine, the façade of a decaying Portuguese church, or a red laterite stone wall, stand out as if lit by strong spotlights. A buffalo cart parked in the shade was barely discernible, so close was it in tone and colour to its surroundings. Other objects, from haystacks to parked motor cycles, loomed enigmatically from the rich shadows. Children called cheerful greetings, older people waved, a mother pointed me out to the child in her arms, who took one look, buried his head in her shoulder – and burst into tears!

Through the trees the distances were difficult to judge. I paused at a wayside drinks stall which stood in the shade. On one of its sides was a hand-painted picture of a large bottle, with a brand name above. I read the carefully lettered description beneath: 'This drink is made from entirely artificial ingredients. It contains no fruit juice or pulp whatsoever.' Other places – other customs! On the drinks tariff I noticed 'Booze Gin', related to another famous brand name, no doubt.

Red soil beneath the palms reflected its colour up onto tree trunks and the undersides of leaves, producing a

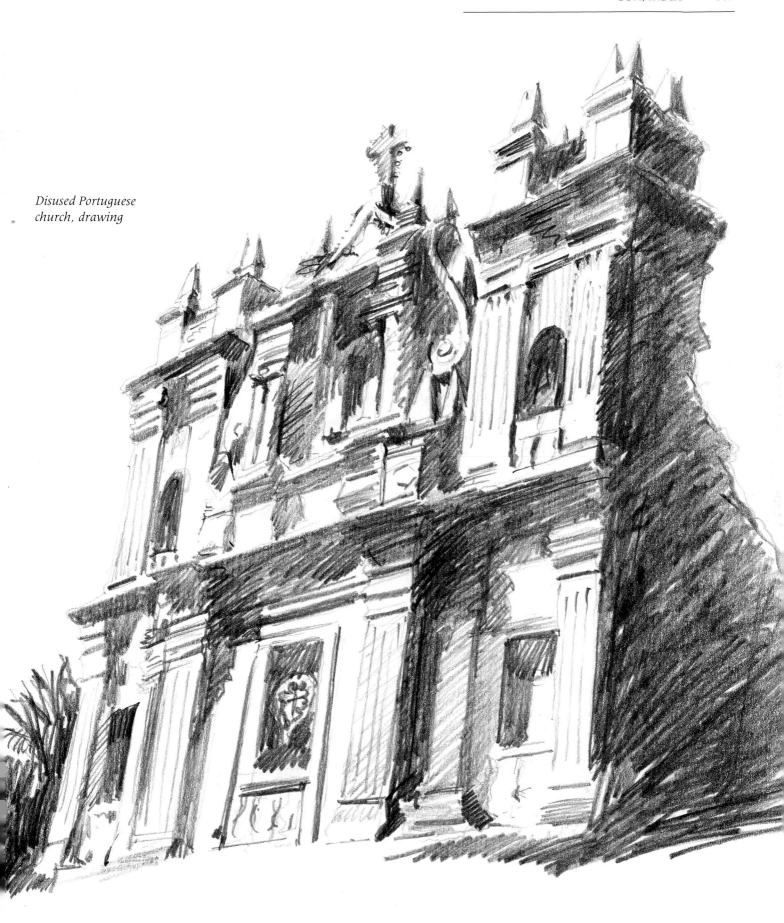

*Disused Portuguese
church, drawing*

strangely glowing effect in the shadows. Then I was out of the dark tunnel and onto the stretch of sunny road that led to the beach. I passed a modest line of tourist stalls and reached a geometrically planted coconut grove marking the end of the beach I had seen the day before. Here the light was reflected from the sea, which showed brilliantly between the tree trunks and made for a sharper and more defined series of forms. The palm-frond shadows were interlaced on the ground as it shaded from red soil into pale sand. Figures moved gently or sat beneath the trees, and the scene had a slow, timeless quality, in contrast to the mystery and shadow I had just left. I stood and made a drawing whilst the smell of spicy food wafted through the palm-leaf walls of a nearby beach restaurant, and long-nosed pigs rooted among the tree trunks.

A different light and colour presented themselves on another day when I walked along a track leading inland amongst clusters of tall palms to the paddyfields. Almost the only traffic was an occasional bullock cart taking rice to be planted. On reaching the paddyfields I found red soil furrowed beneath the water, while blue sky reflected off the surface, producing a pale violet in the full sun and strong purple in the shadows of trees near the water's edge. More distant fields shaded from violet to blue, with

The Buffalo Cart

After experimenting with an underpainting of red in my watercolour The Bungalow *(shown on pp. 116–17), I decided to try a red ground in this oil painting of a cart in the mottled shade of trees, in order to convey the warmth and reflected light within the dense shadows. I rubbed a mixture of Cadmium Red and Alizarin Crimson, well thinned with turpentine, into the grain of my canvas, using a rag. Large passages of dark were placed with French Ultramarine and Winsor Blue; Alizarin Crimson was added for emphasis. Light accents were added last when the lower tonal range was established. Oil on canvas, 41 × 66 cm. (16 × 26 in.)*

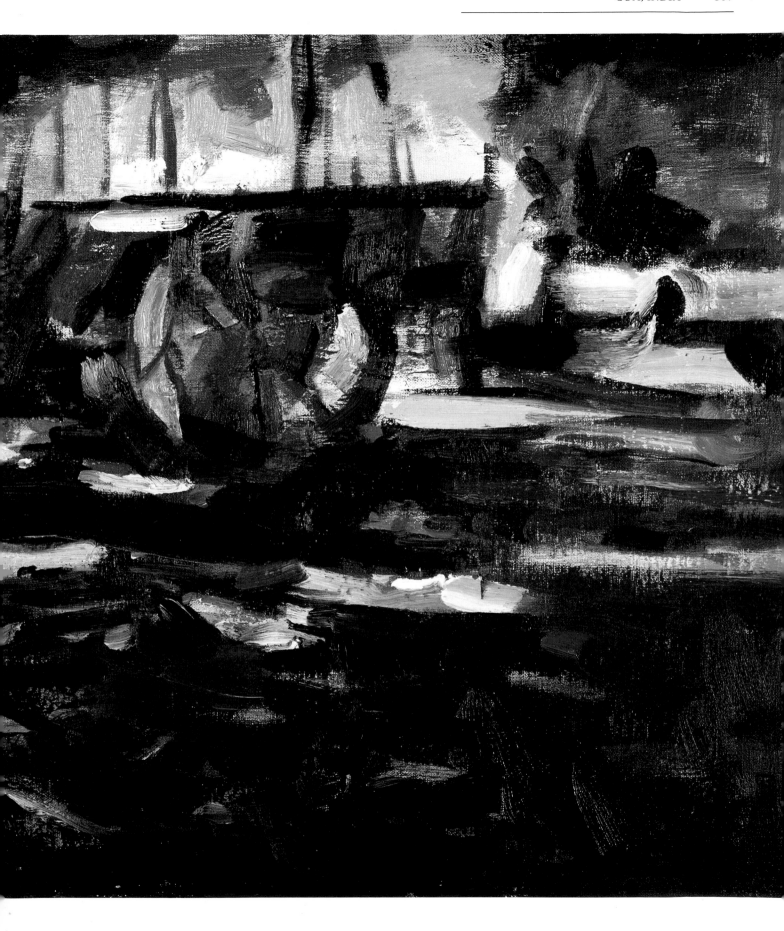

Coconut Grove, Goa

Red soil merged into sand as I approached this coconut grove on the Goan coast. The breeze from the sea moved the stiff palm fronds, creating a shifting shadow pattern which was itself complemented by the graceful figures of local people. The atmosphere was humid following the monsoon, and in the soft sunlight the greens of the undersides of the branches were warmed by reflections from the ground. I used tones of blue to create the complex grouping of palm-tree trunks and overhead foliage, following this with washes of yellow and crimson for the strong, deep shadows. The sharp-edged strip of blue-grey seen through the palm trees offered a strong horizontal note, and for this I used French Ultramarine mixed with a little Cadmium Red. Watercolour, 56 × 74 cm. (22 × 29 in.)

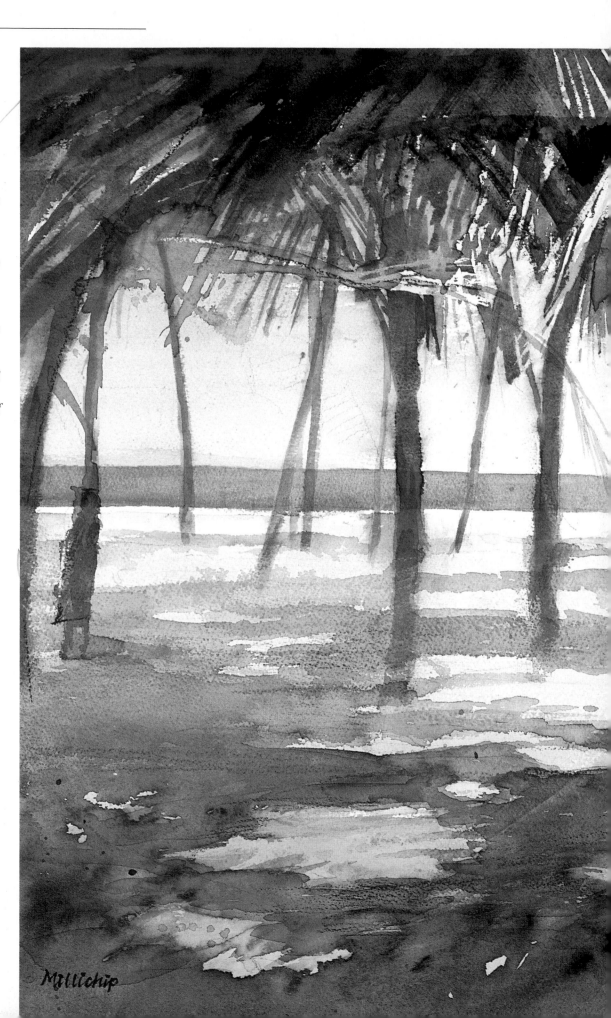

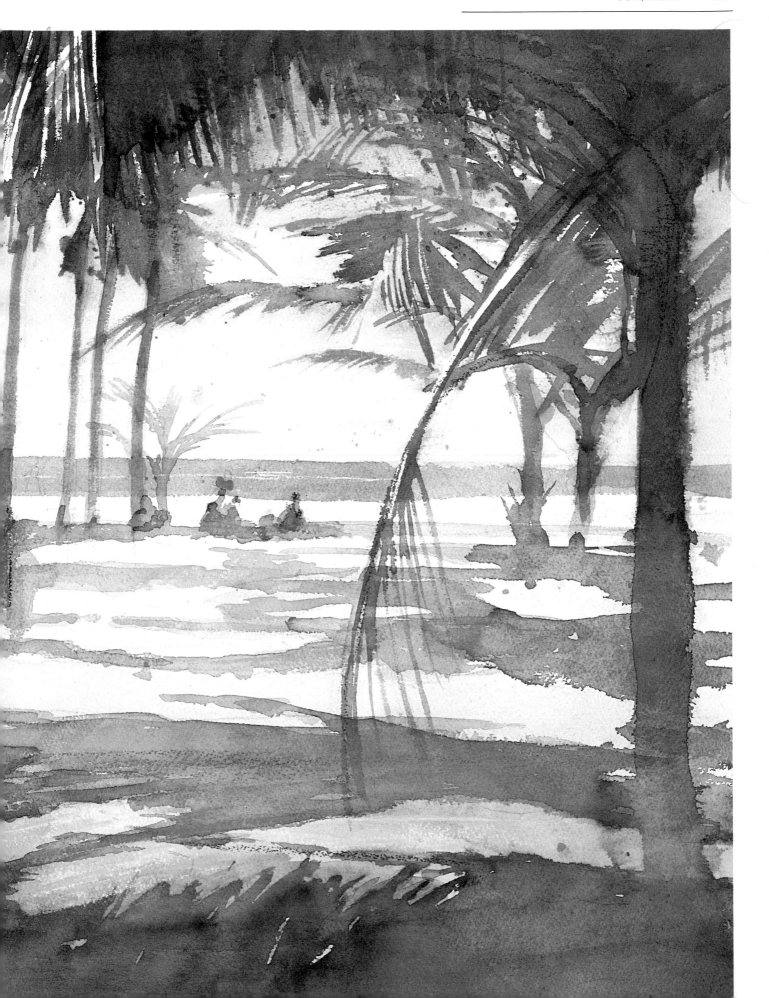

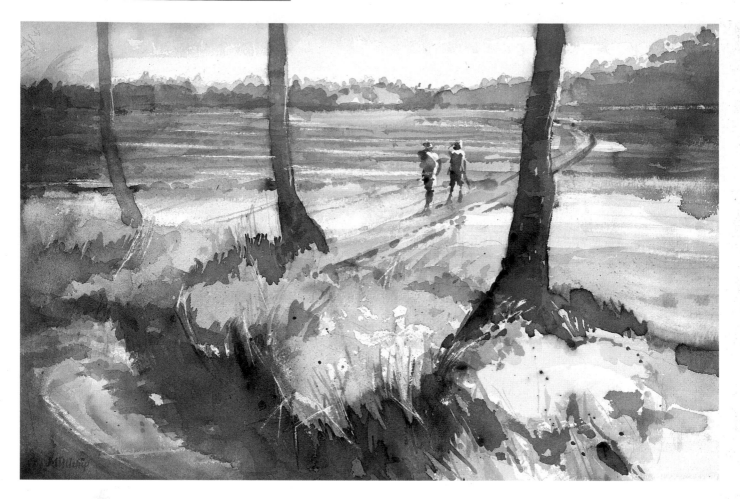

Paddyfields

A few minutes' walk away from the sea, the landscape and the light change completely. The reflective surfaces of the flooded fields and the soft, humid atmosphere now prevailed. I began my painting with blue to blue-violet washes (French Ultramarine and dilute Alizarin). This first phase was strengthened by further washes of crimson and blue on the foreground palm-tree trunks and the ditch. A little scraping with a scalpel helped establish grass texture and light on tree trunks. Watercolour, 36 × 54 cm. (14 × 21 in.)

straw-hatted peasants working along the furrows and white buffalo slowly pulling the ploughs: a truly pastoral scene.

Exploring this lovely area of Goa was one thing – starting to record and interpret it was another. The beach seemed a good place to begin work; I decided to make a modest study, incorporating some of the long bamboo rods pushed into the sand, usually as structures for palm-leaf shelters, as a way of defining the broad stretches of beach. The sun was high and hot that morning, but I was working in a convenient palm shelter and hoped to be relatively undisturbed. Looking into the sun, which presented a beautiful hazy-blue distance, I saw the silhouette of distant Aguada Fort and the headland with the scrub-topped dunes nearer to hand. All painters know how the intense concentration painting demands means that you become lost in your work. Fairly soon my 'lost' state was

interrupted by a tug at my sleeve and an invitation by a beach fruit-seller to view and buy from a selection of pineapples, bananas and oranges. I refused politely but was met predictably with more insistent demands. Then came a tweak on the other sleeve and another invitation to choose from a display of tropical shells.

Concentrating as best I could on the problem of bringing out the sand foreground of my study with a light wash of Cadmium Red, I suddenly realised that a dark hand was holding a grubby card between myself and my work. On the card I read, 'I am a licensed qualified ear cleaner. Can clean sand and other dirt from ears painlessly.' This I felt was a sign that I should extricate myself with as much tact and grace as I could muster, leaving the palm shelter to the local traders, who no doubt had more right to it than I!

An hour or so later I was eating lunch at

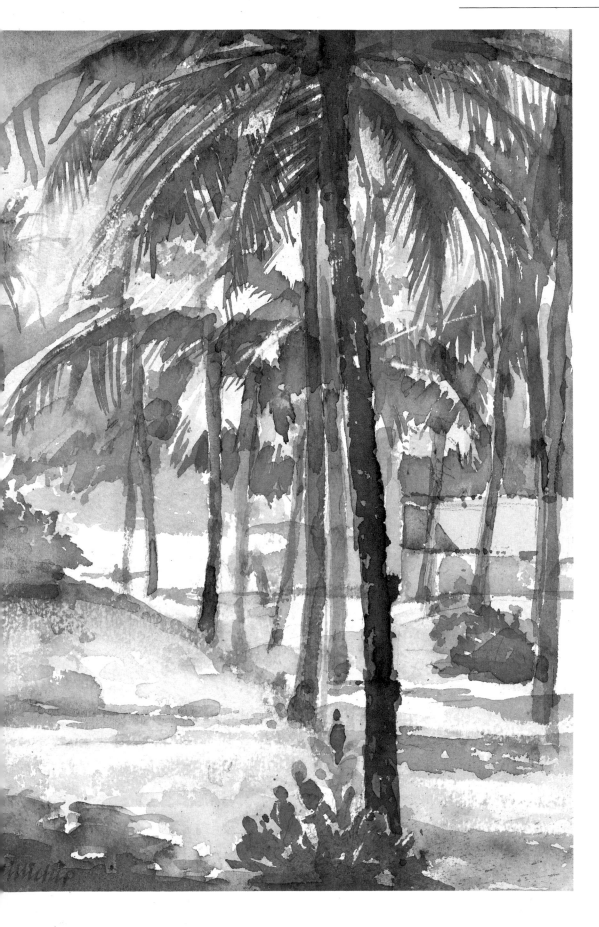

Coconut Trees, Calangute

These trees were growing in very sandy soil near the beach, and I wanted to capture the sense of light – reflective, warm, but in this case not pink – bouncing up from the ground onto the undersides of the palm fronds. The lighter background fronds went in first, and for these I used pale Winsor Yellow and a little ochre. For the darker greens of the foreground, Cadmium Red was added to a Winsor Blue/Winsor Yellow mix. It was also mixed with blue to establish the dark tree trunks. Plenty of water was needed to keep the paint fluid on a very warm day.
Watercolour,
36 × 26 cm.
(14 × 10 in.)

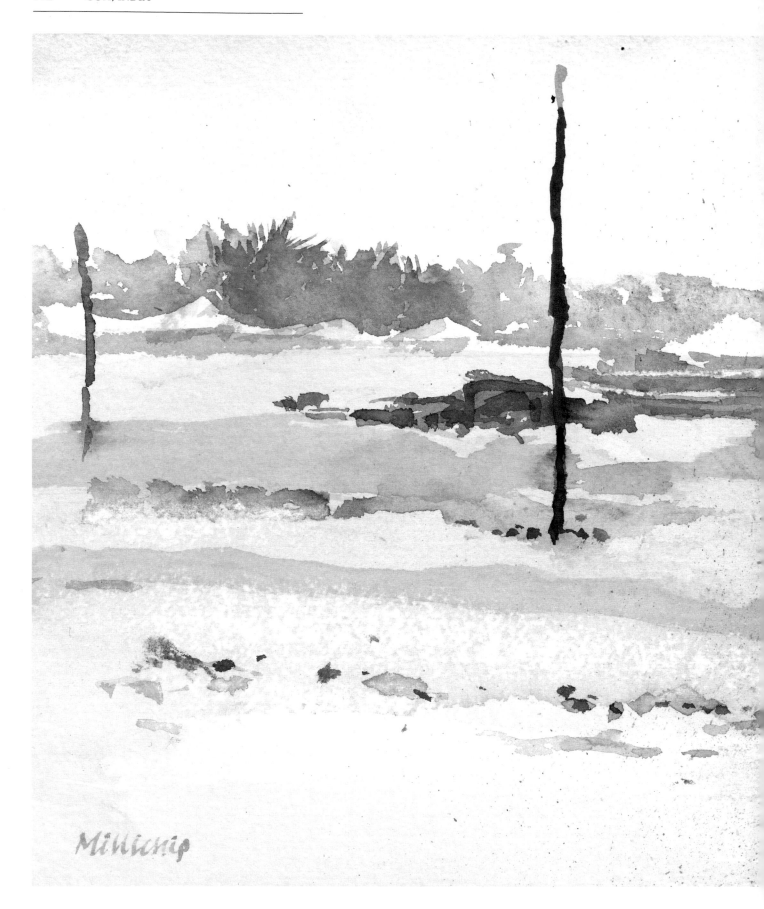

Millichip

a beach café and looking out towards a group of local fishing boats drawn up on the sand. Designed to be launched into the fierce breakers of the Arabian Sea, these are dark-tarred and narrow-hulled vessels with a balancing outrigger. They make powerful jutting shapes, and I realised that the light that morning, shining from behind the group of boats, would emphasise their silhouettes and rugged quality. I drew from the café, with no interruptions this time, and later used the study as the basis for an oil painting. The ubiquitous fruit-sellers and carpet traders passing and repassing along the beach made for colourful notes against the dark boats.

By now I was beginning to understand the painting potential of daylight on the beach in this part of Goa – how the light reflected from the sea gave clarity yet flattened forms, emphasising the outer edges of shapes. A kilometre or so inland was, as I knew, another scene, and I decided to sit and paint in the dappled shade of the village, where forms and colours were camouflaged and fragmented by the different light. I chose for a subject a red-roofed colonial-style bungalow glimpsed through a grove of coconut and other trees and decided to make a small study of this in colour. A quick tonal drawing in my sketch book came first. This established the relative darkness of an angled foreground tree trunk, which I hoped would hold in place the distant acute dark of the bungalow's doorway. 'Yellow-pink light reflects up

Towards Calangute

This small study, which is reproduced here actual size, was made to explore the spatial possibilities as I looked into the sun in the hazy light of early morning. My work was soon interrupted by beach hawkers, as described on p. 110.

Watercolour, 23 × 33 cm. (9 × 13 in.)

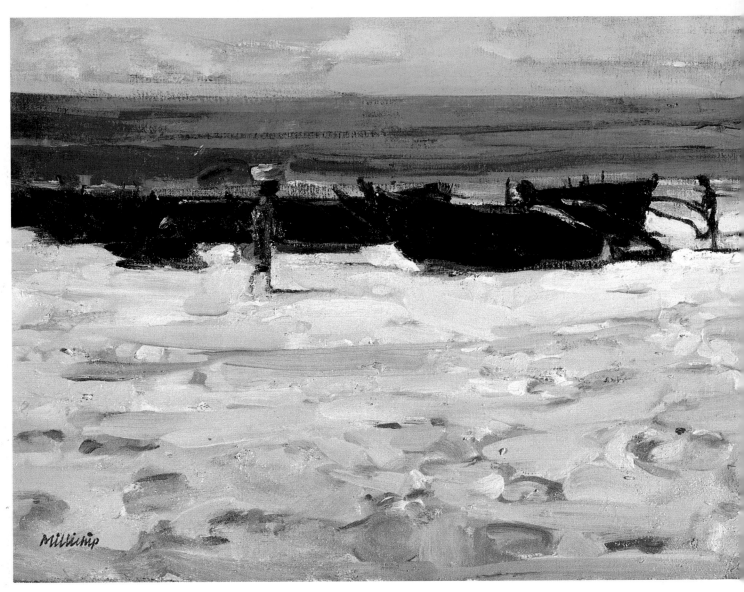

from ground' says my note on this drawing, and I started with a structure of Yellow Ochre and Cadmium Red to underlie the whole study and convey the sense of warm shade. When this was dry (it didn't take long) I floated blue washes over it to articulate the darker areas, letting plenty of the warm underpainting show through. It seemed time to check whether all this effort was getting me anywhere, so I stood up and placed my painting on the ground to view it from a distance. In the process I nearly knocked over a hitherto unexpected watcher, a young local man who had been examining silently the work in progress. Shyly he showed me for approval a simple crayon drawing he had made of the bungalow as he watched me. I often find that spectators are moved to try their hand themselves whilst watching a painter at work.

This first foray into painting in the shadowed light of Baga village seemed to call for a more intense look at the nature of shadows cast by the eaves of buildings standing in patches of brilliant sunlight. Part of the painter's business is to look hard and then look even harder – successful painting lies in the art of seeing rather than in manipulating paint. I sat and drew a pantiled roof and the shadow it cast on a brilliant white wall. 'Warm shadow, little reflected light in it' reads

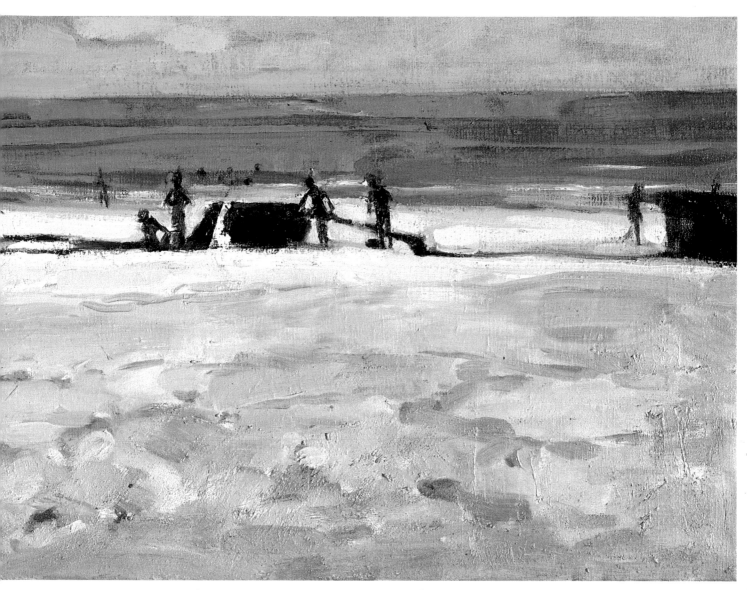

Fishing Fleet, Baga Beach

The frieze-like grouping of boats and figures on this ever-active beach was assembled from sketch-book drawings made after lunch, when I was sitting at a beach café. I used the sea as a background to link boats and people, relying mainly on silhouetted shapes to give character to the scene. A slightly overcast day resulted in a flat light in which local colours, such as the orange dress of a fruit-seller, stood out. The painting was constructed over a blue ground and I tried to seek out as much colour as possible in the dark areas. Oil on canvas, 38 × 102 cm. (15 × 40 in.)

(Left) Detail, I used a painting knife to place the figure with a mixture of Cadmium Red and Winsor Yellow.

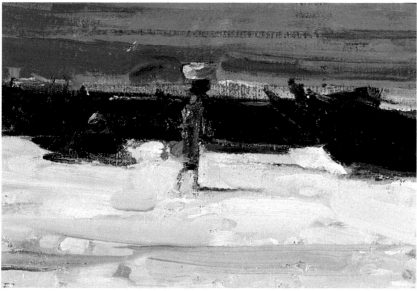

The Bungalow

Painted on site, and reproduced actual size. The working method is described on pp. 113–14. The initial red underpainting can be seen through dark yet transparent washes. Watercolour, 26 × 36 cm. (10 × 14 in.)

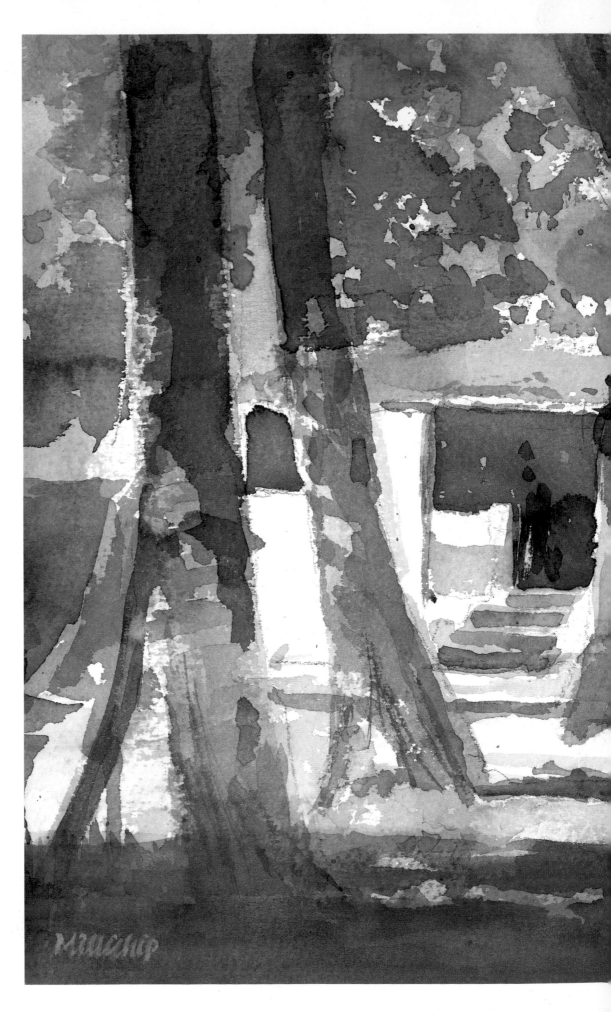

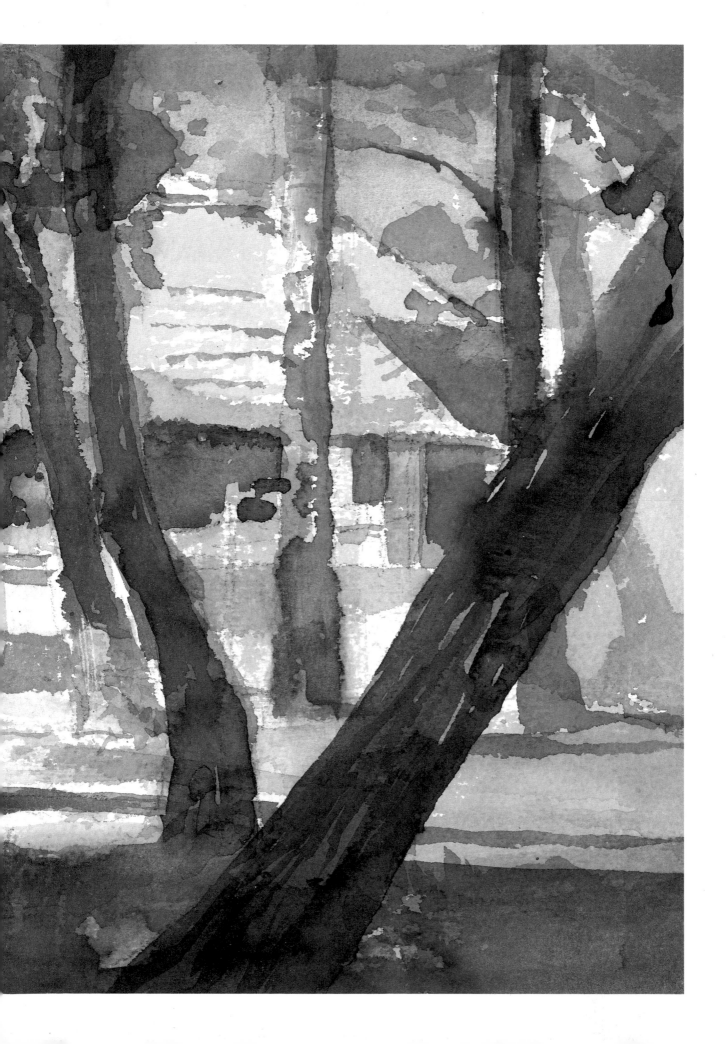

my note for this. It was around noon and I thought how different such a shadow might have been in the diamond-sharp light of Greece. As I drew, the life of the area carried on around me: a local bus rattled past, hooting wildly; a cyclist came along; a goat clambered into a tree nearby and began munching succulent leaves. My study developed into an idea for a large watercolour, which I carried out later in my studio in Britain.

Painters will know that there are some days when even the most promising venue seems to yield nothing that attracts them to draw or paint, while on other days, potential subjects seem almost to be lining up for their attention. I had just finished my shadow study when I turned round and saw that the shrine outside the house on the other side of the road stood in a shaft of sunlight, which just caught the corner of a dilapidated Portuguese mansion behind it. Quick, out with the sketch book, make notes, capture that figure watering the plant on top of the shrine before she disappears, render some texture, check the position of the sun, evaluate the tonal scale, determine the predominating colour . . . Who knows, there may be the makings of a picture here!

After all this excitement some lunch and a siesta seemed in order and, in fact, it was a day or two before I ventured again down the track to the paddyfields, this time to look harder and to try to convey that beautiful, pearly violet light which the flat, reflective, waterlogged fields produce in this area. As I sat and drew, a small brown fist was thrust at me, filled

Sketch-book study of roof and shadows, shown actual size

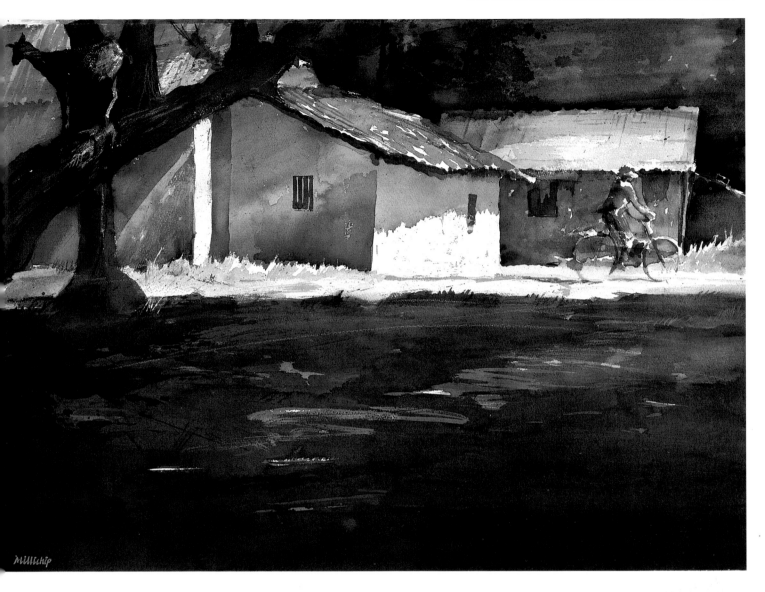

with a bunch of the exquisite wild lilies that grow in the corners of the paddy. As I took the flowers, out shot another hand to claim the inevitable rupees. After receiving payment the young flower-bearer paid out the fellow members of his syndicate and ran off, grinning, to pick more flowers. Meanwhile I was still trying to make sense of the relationship between the rigid lines of paddyfield furrows and the luminosity given to them by a somewhat obscured sun. The lines of foreground trees edging the cultivated areas proved useful here. Certainly the scene had a poetry of its own and was very different, both in light and content, to anything I had encountered elsewhere.

Goat and Cyclist

This painting was prompted by a colour study of the shadows cast by the house eaves (see p. 114). As with several other of my Goan paintings, I also wanted to explore the potential of colour in the strong, rich shadows beneath the high but dense foliage. The main dark passages were placed first with washes of Alizarin Crimson. When these were dry, foreground work was added with masking fluid, followed by strong washes of Ultramarine. Tilting my board, I allowed these to settle at the lower edge of the painting. Greens were created with overwashes of Winsor Yellow, and the darks with washes of Winsor Blue. A little crayon work accented some darker areas. Watercolour, 53 × 74 cm. (21 × 29 in.)

Two Trees

This painting involved a similar approach to that of Goat and Cyclist *(p. 119). I aimed to capture a moment when sun spotlit the shrine at the corner of the house, and also the texture of the foreground tree trunk as the house-owner hurried back into the shadows. The crimson underpainting established the structure of the painting. Blue washes were followed by yellow to create a dense rich surface. A very dark area at the top was made by mixing Winsor Blue, Ultramarine and Alizarin Crimson, flooding these on while tilting the board upwards, and pouring on more colour as the paint began to dry. Watercolour, 53 × 74 cm. (21 × 29 in.)*

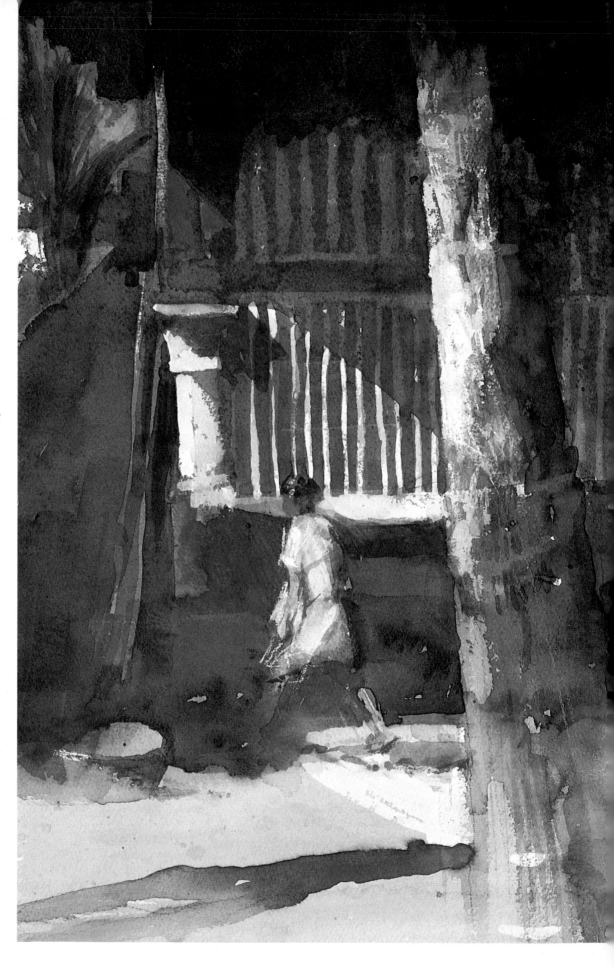

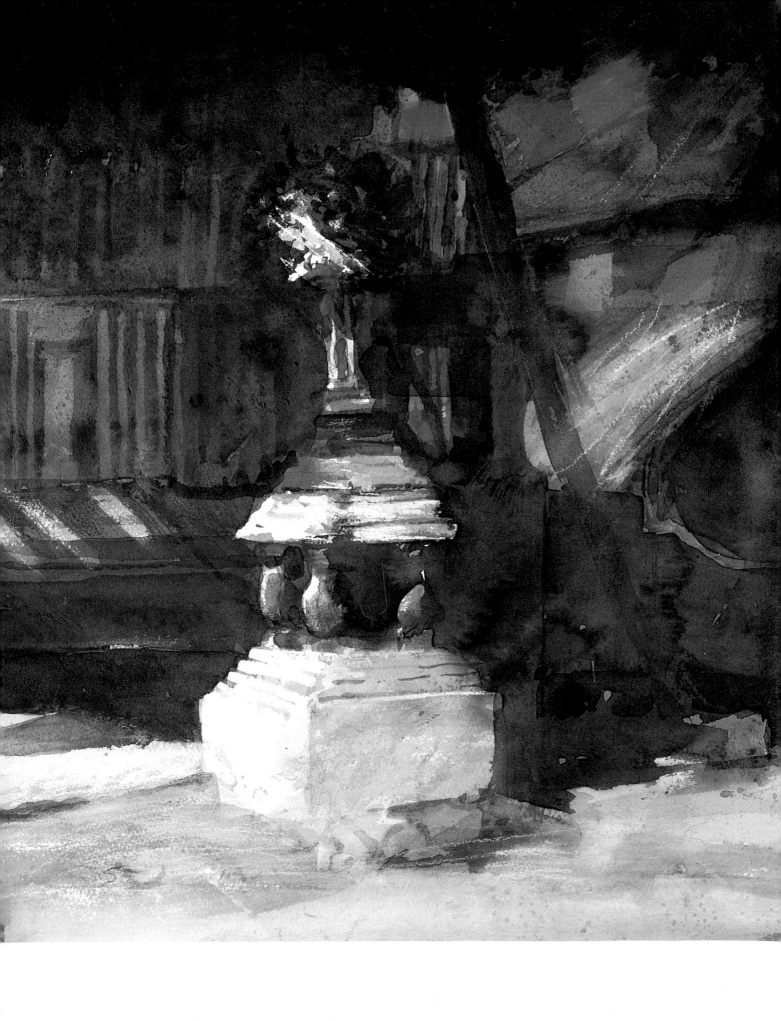

16/11
paddy fields
nr Andrusa road . humid day . Cloudy sun indistinct edges

Sketch-book crayon study of paddyfields, shown actual size

Warm, moist air made for forms and atmosphere that were a long way from the qualities of light in the dry air of Morocco or the clear air of Greece. It was not until I returned home that I felt able to recollect my impressions in tranquillity and attempt a painting.

Goa is a tiny state in relation to the immensity of India but its lush and varied countryside and superb coastline offer enough variety to please the most fastidious painter. About four hundred years of colonial rule by the Portuguese have left their mark in the form of innumerable baroque religious buildings, from cathedrals to picturesquely decaying chapels. Large colonial-style houses abound as well, and make for fascinating subjects. Other painting possibilities range from the elegant nineteenth-century lighthouse at Aguada to a boat-building yard full of thatched boats near Chapora. Naturally the people of Goa are an integral part of the scene and their colourful dress is always a delight, whether they are seen grouped round a street drinks-vendor or in family parties strolling along the shore. The nature of the light varies from that of the coast to the richly shadowed areas further inland. Of course, the time of year is also an important factor, as the monsoon will affect the amount of moisture in the air and thus the strength or softness of the light.

For travelling painters looking for a new visual experience or for those who would like an easy introduction to India, Goa with its sub-tropical light is a wonderful venue.

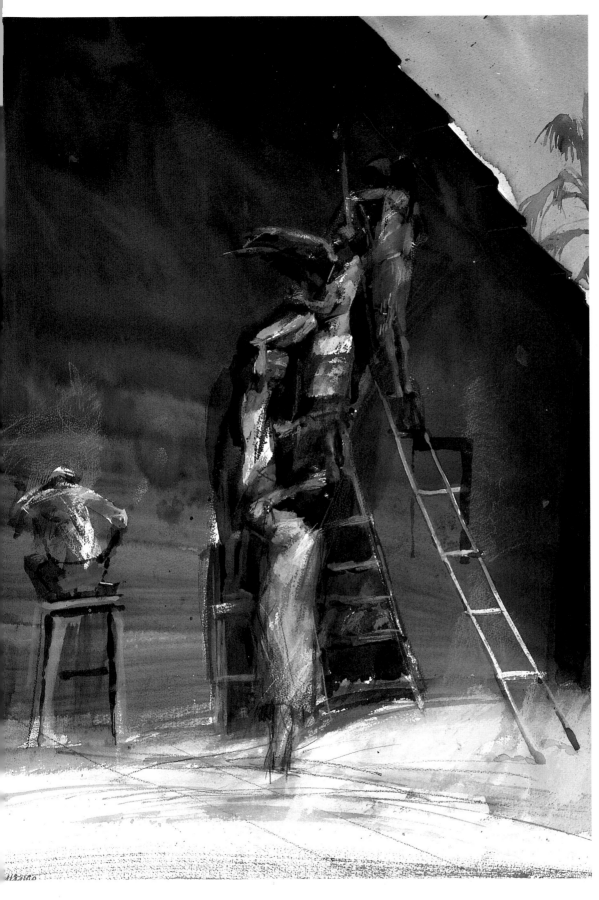

Rendering the Laterite

Just after a very heavy shower, with the sun still obscured, a group of builders were keying a wall of laterite (the local red stone) and applying cement rendering. The atmosphere was thick and heavy but the workmen and their ladders related dramatically to the wall, like some latter-day painting of the Deposition. I used a very heavy wash of Cadmium Red, Alizarin Crimson and Winsor Blue to catch the strong, dark nature of the laterite, and added some crayon and chalk to bring out the flashes of colour in the figures. Watercolour, 71 × 51 cm. (28 × 20 in.)

*Thatched boats at
Chapora, drawing
shown actual size*

Boatyard. goa.

INDEX

page numbers in *italic* refer to illustrations